# A Moment.

# Master Photographers: Portraits by Michael Somoroff

DAMIANI

→ FRANCES MCLAUGHLIN-GILL, NEW YORK CITY, 1978

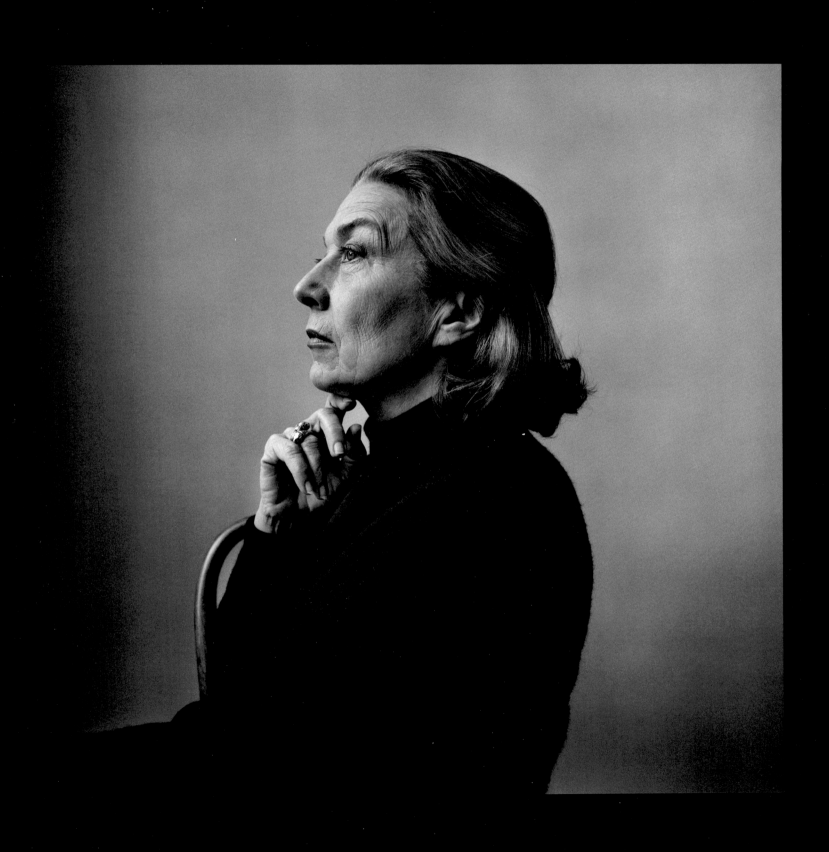

→ CORNELL CAPA, NEW YORK CITY, 1978

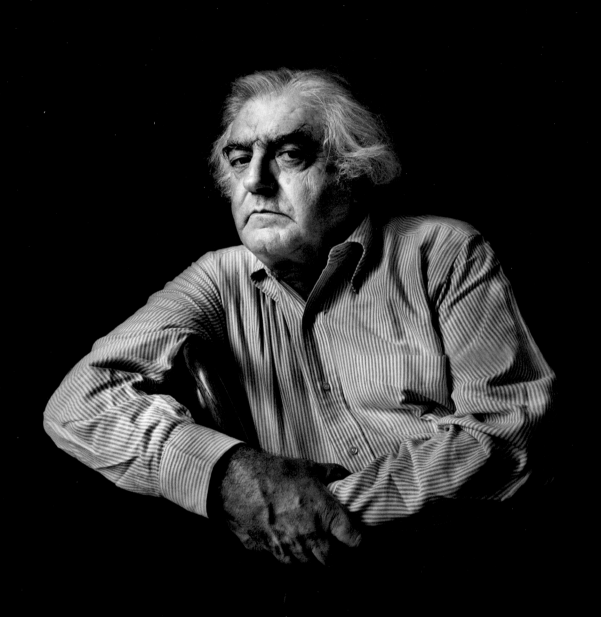

→ ART KANE, NEW YORK CITY, 1979

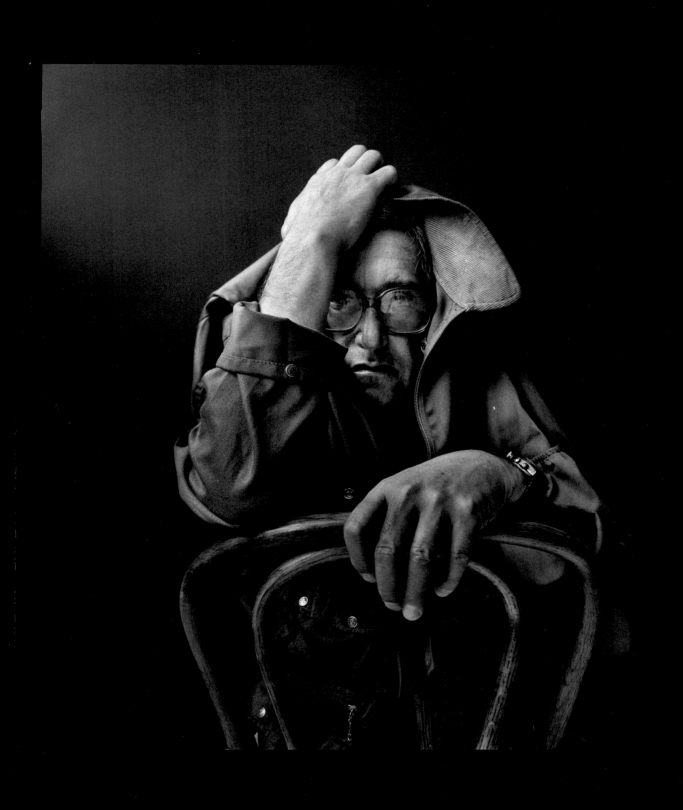

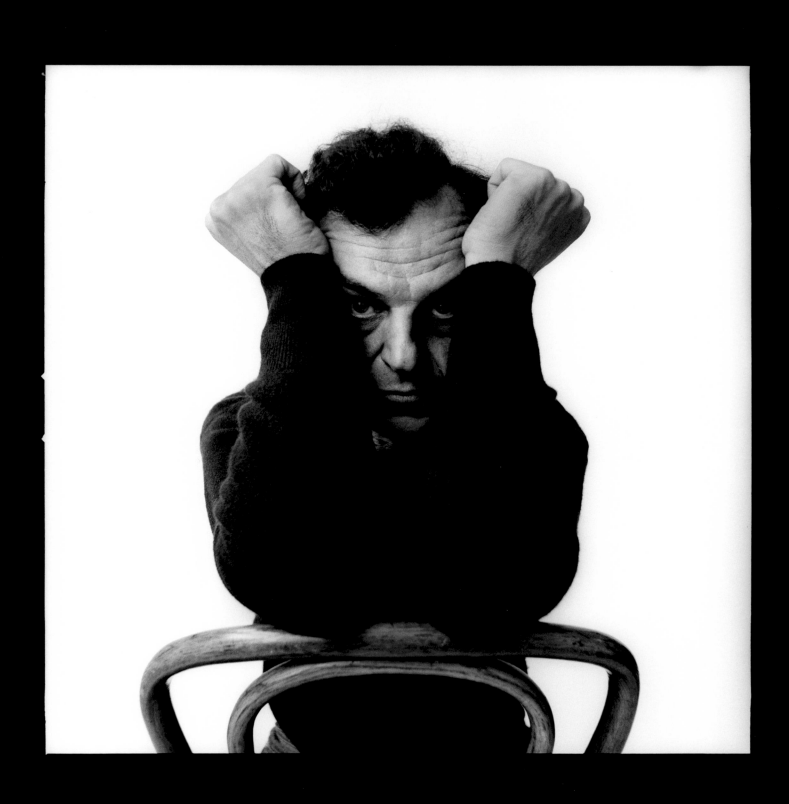

→ BEN SOMOROFF, NEW YORK CITY, 1977

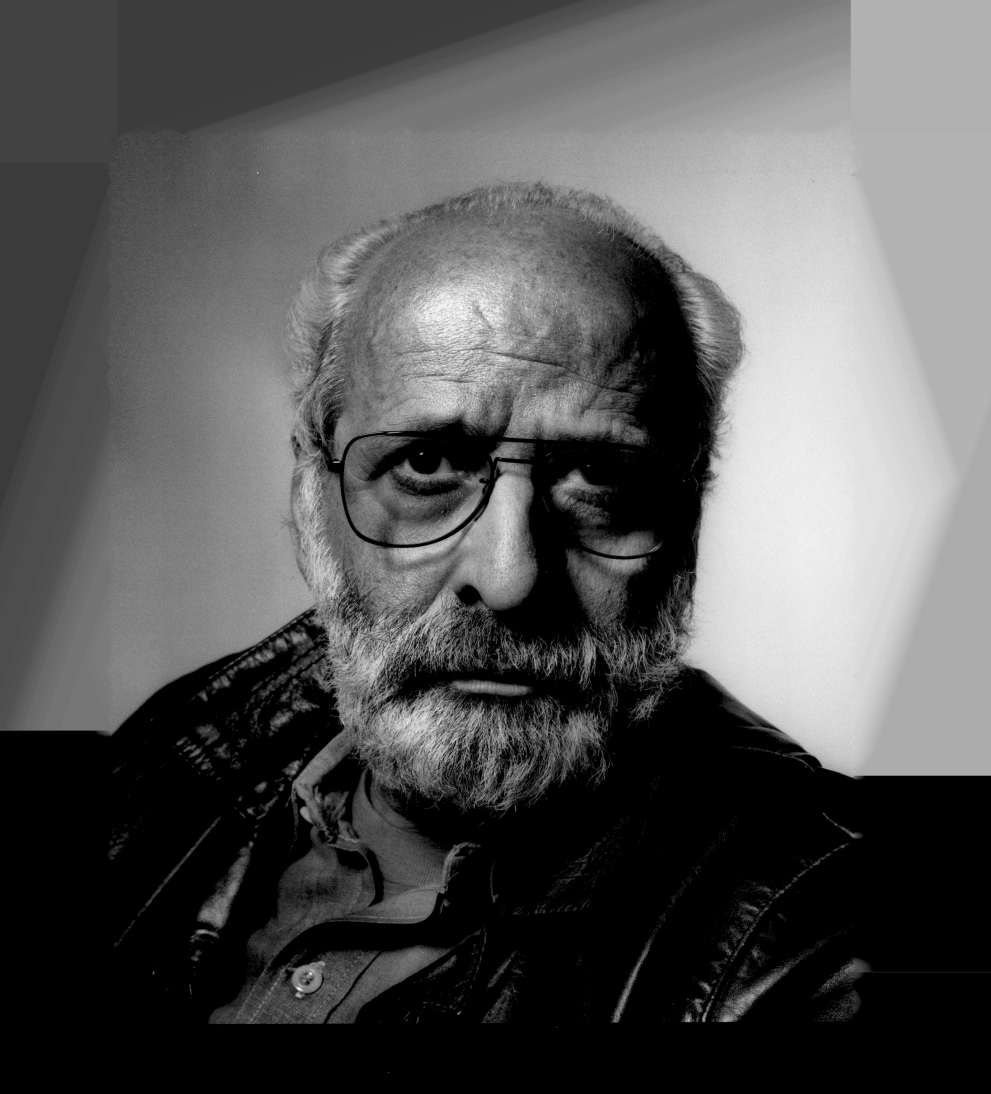

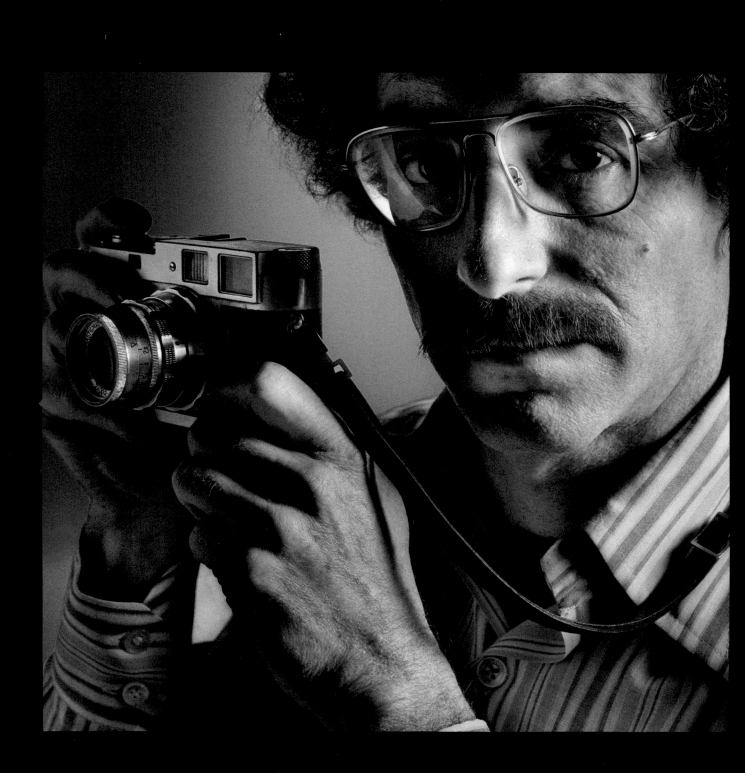

→ HERMAN LANDSHOFF, NEW YORK CITY, 1979

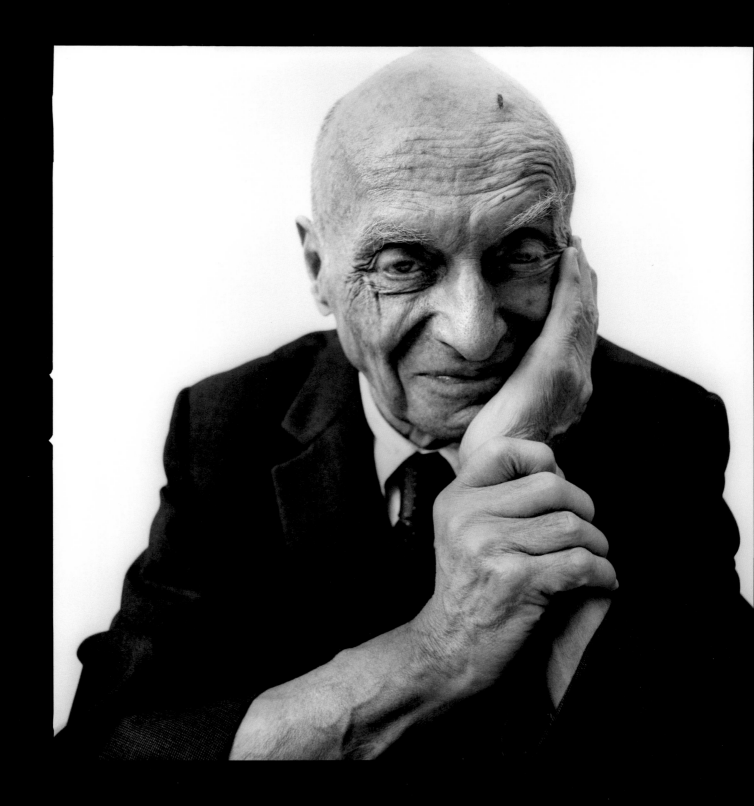

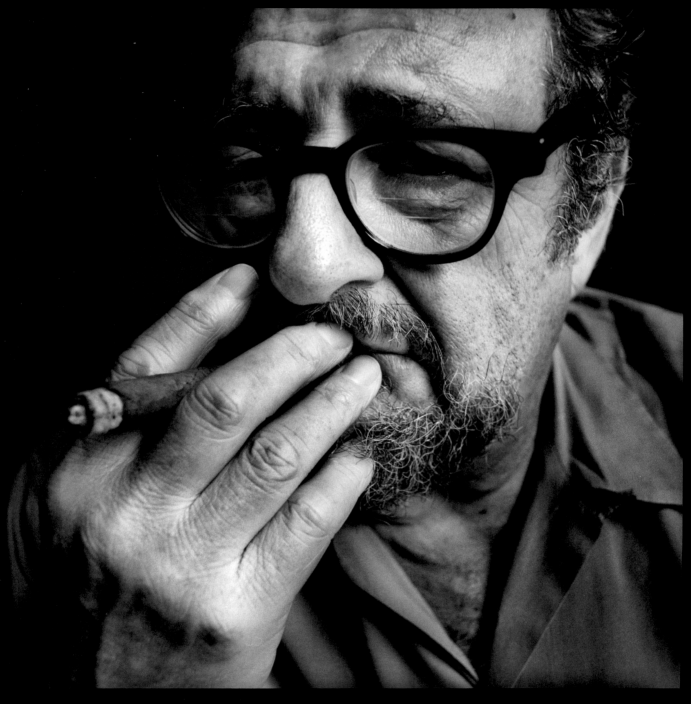

→ HORST P. HORST, OYSTER BAY, NEW YORK, 1980

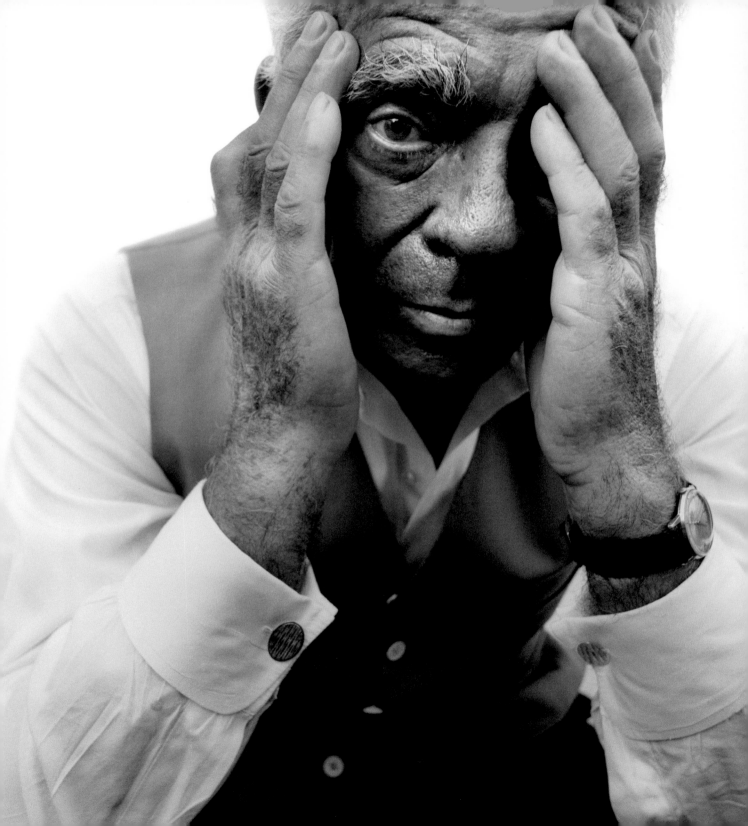

→ ELLIOTT ERWITT, EAST HAMPTON, NEW YORK, 1980

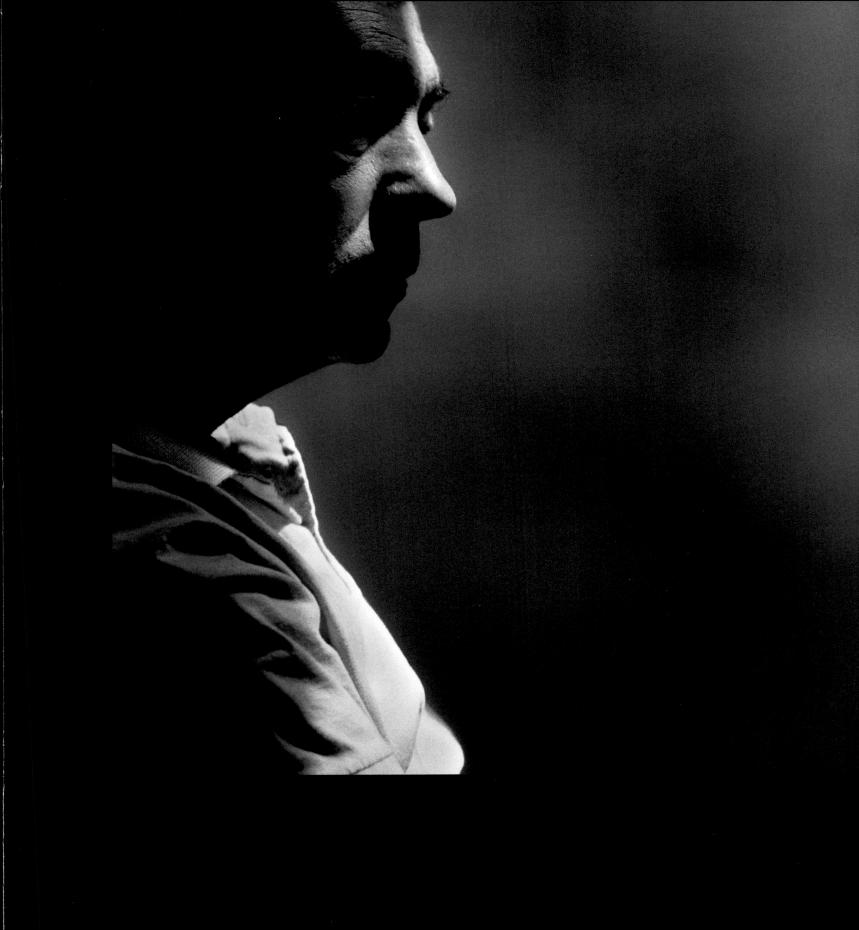

→ ERNST HAAS, NEW YORK CITY, 1980

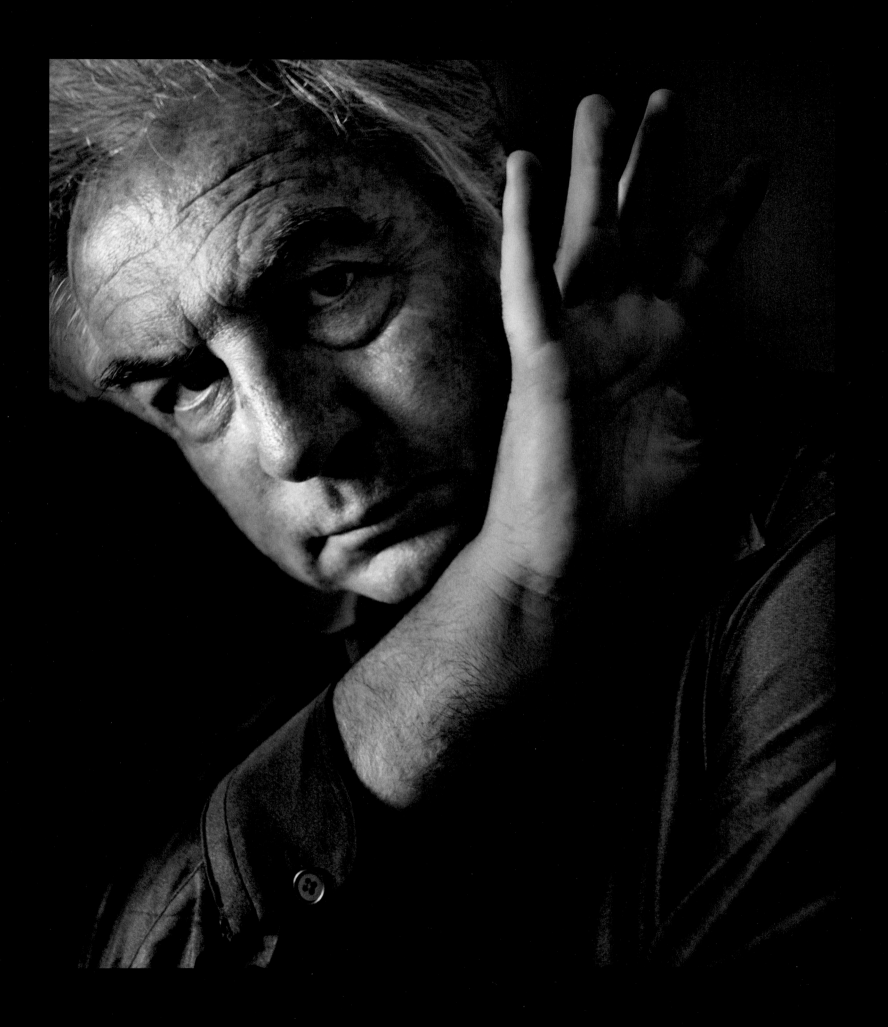

→ RALPH GIBSON, NEW YORK CITY, 1980

→

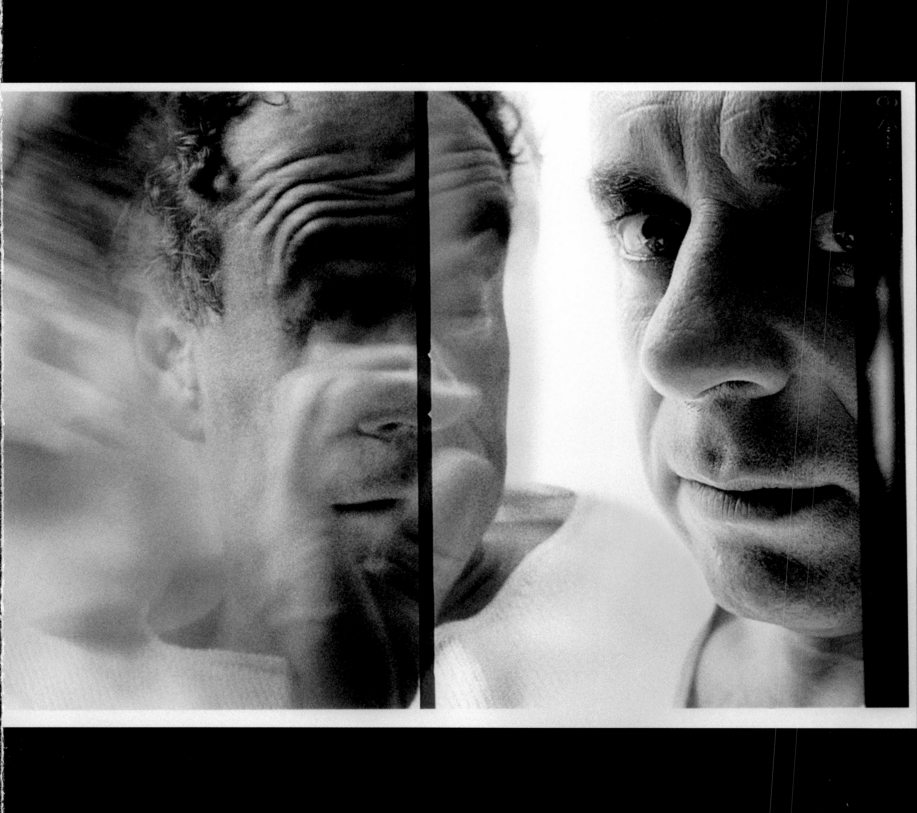

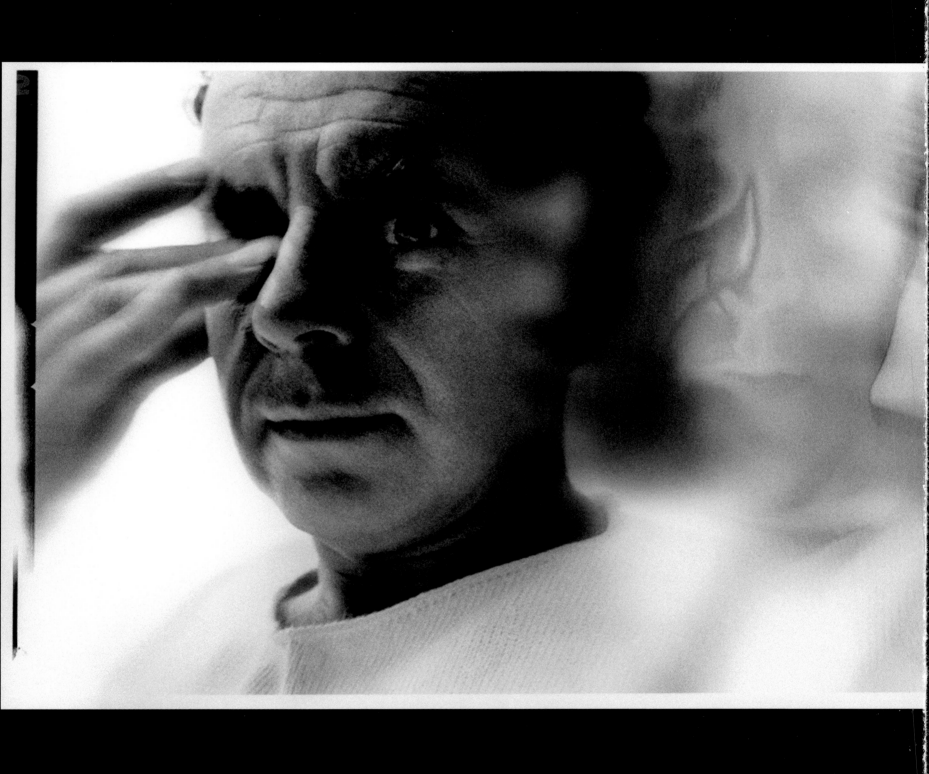

→ ANDREAS FEININGER, NEW YORK CITY, 1980

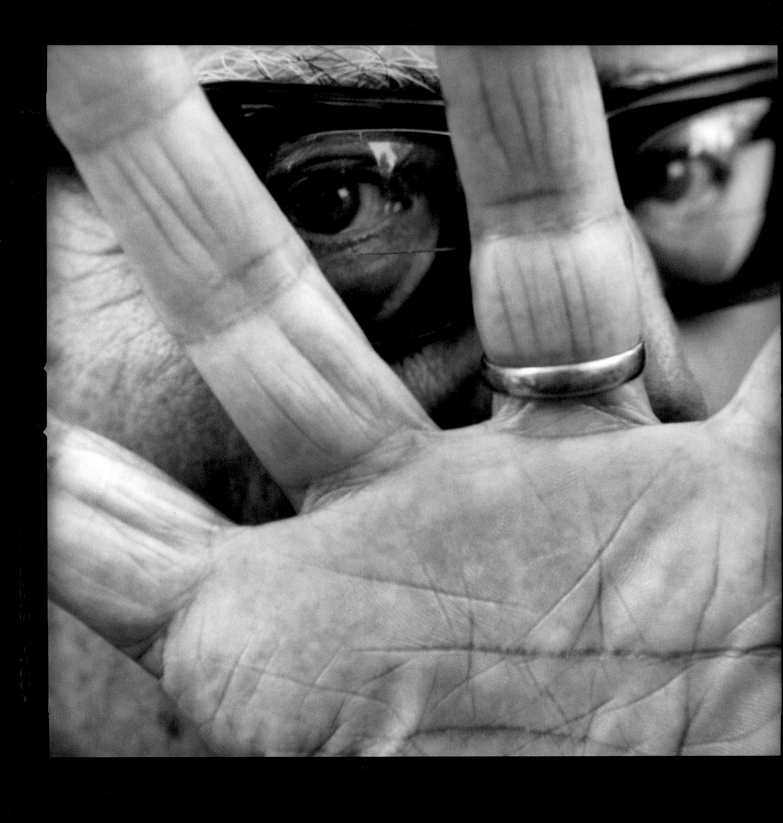

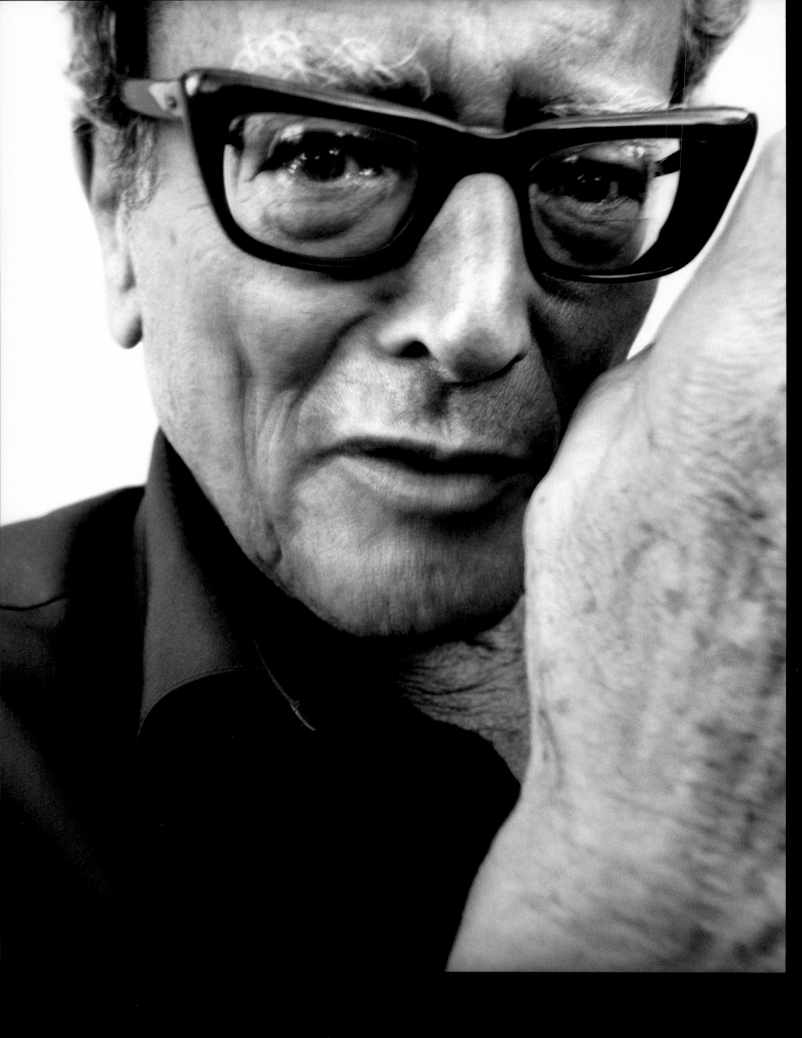

→

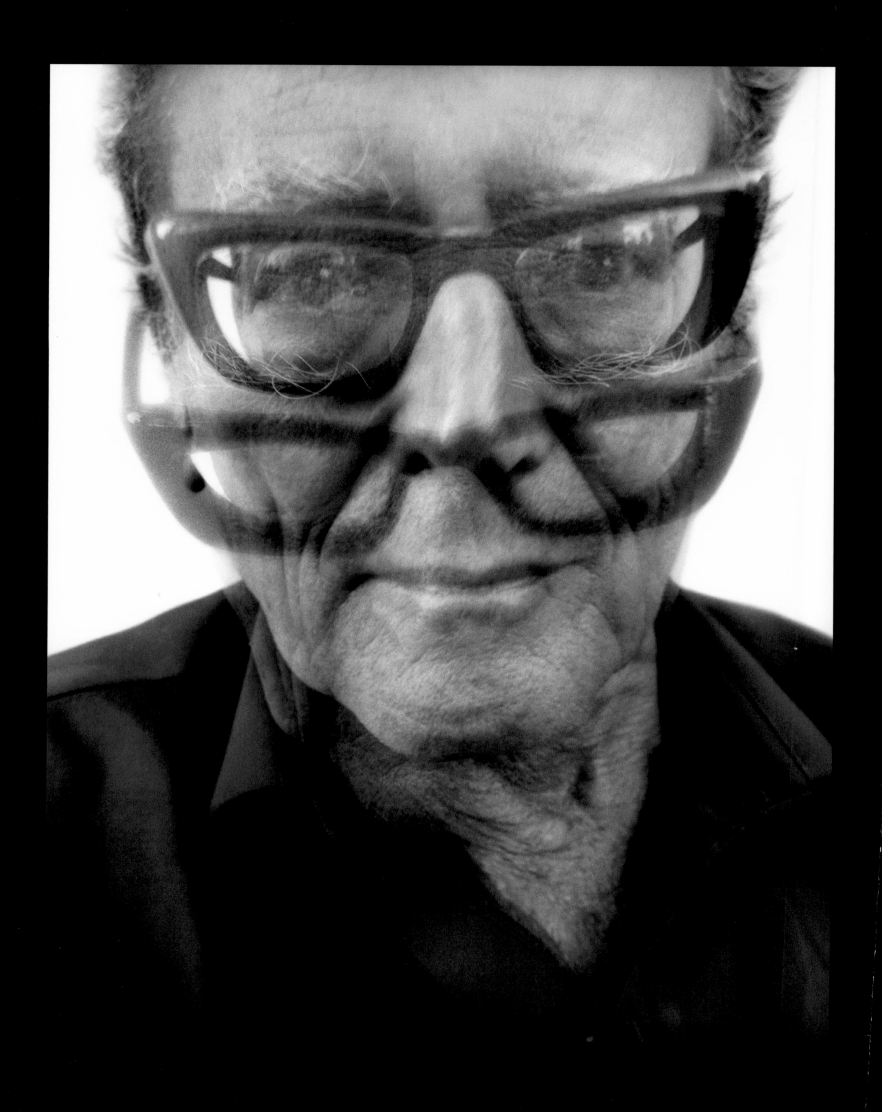

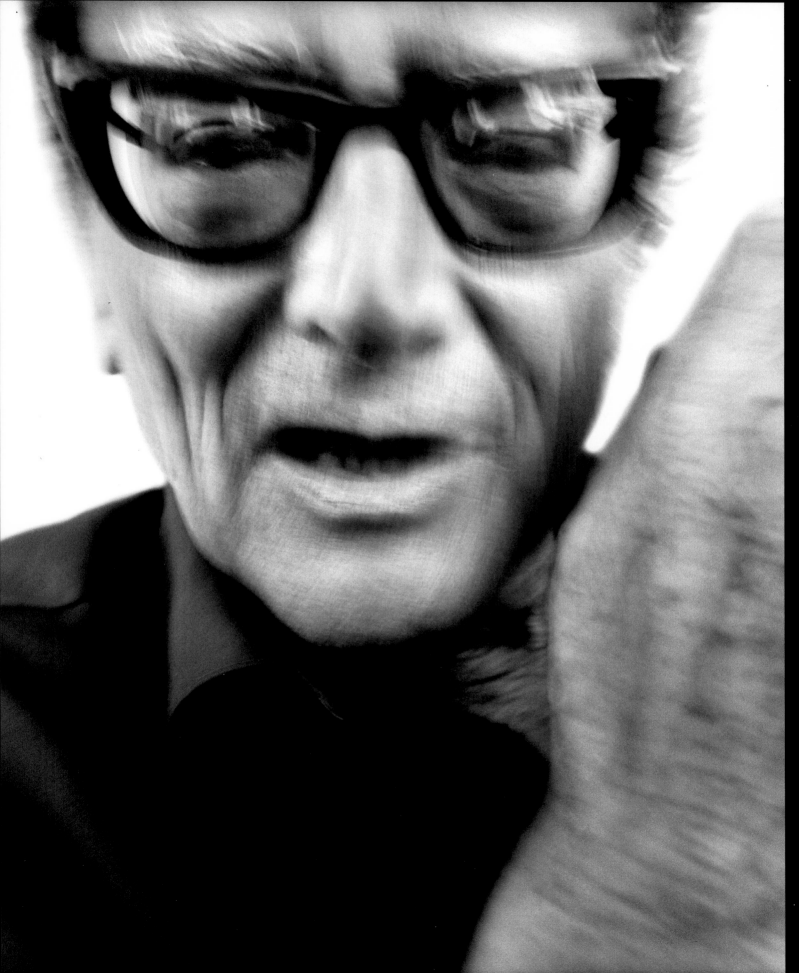

→ ALFRED EISENSTAEDT, NEW YORK CITY, 1980

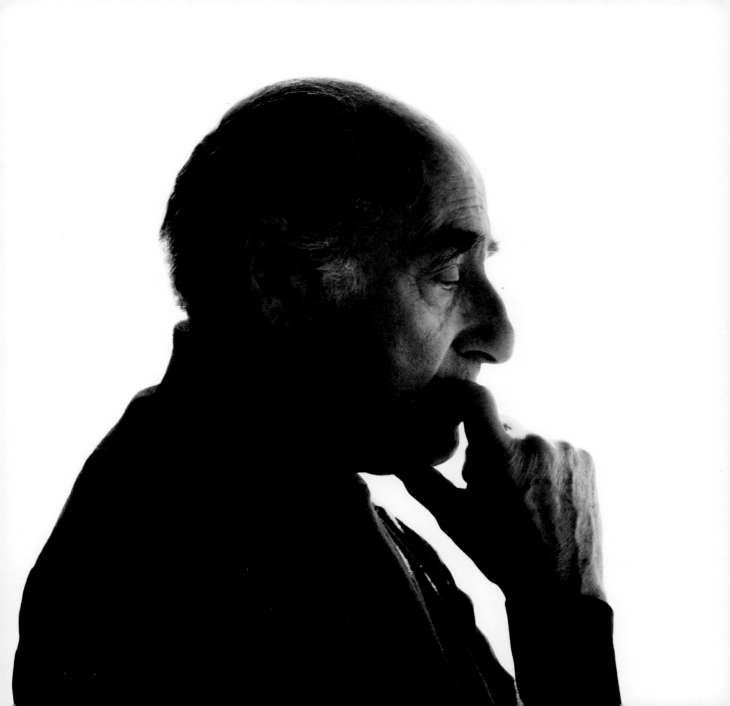

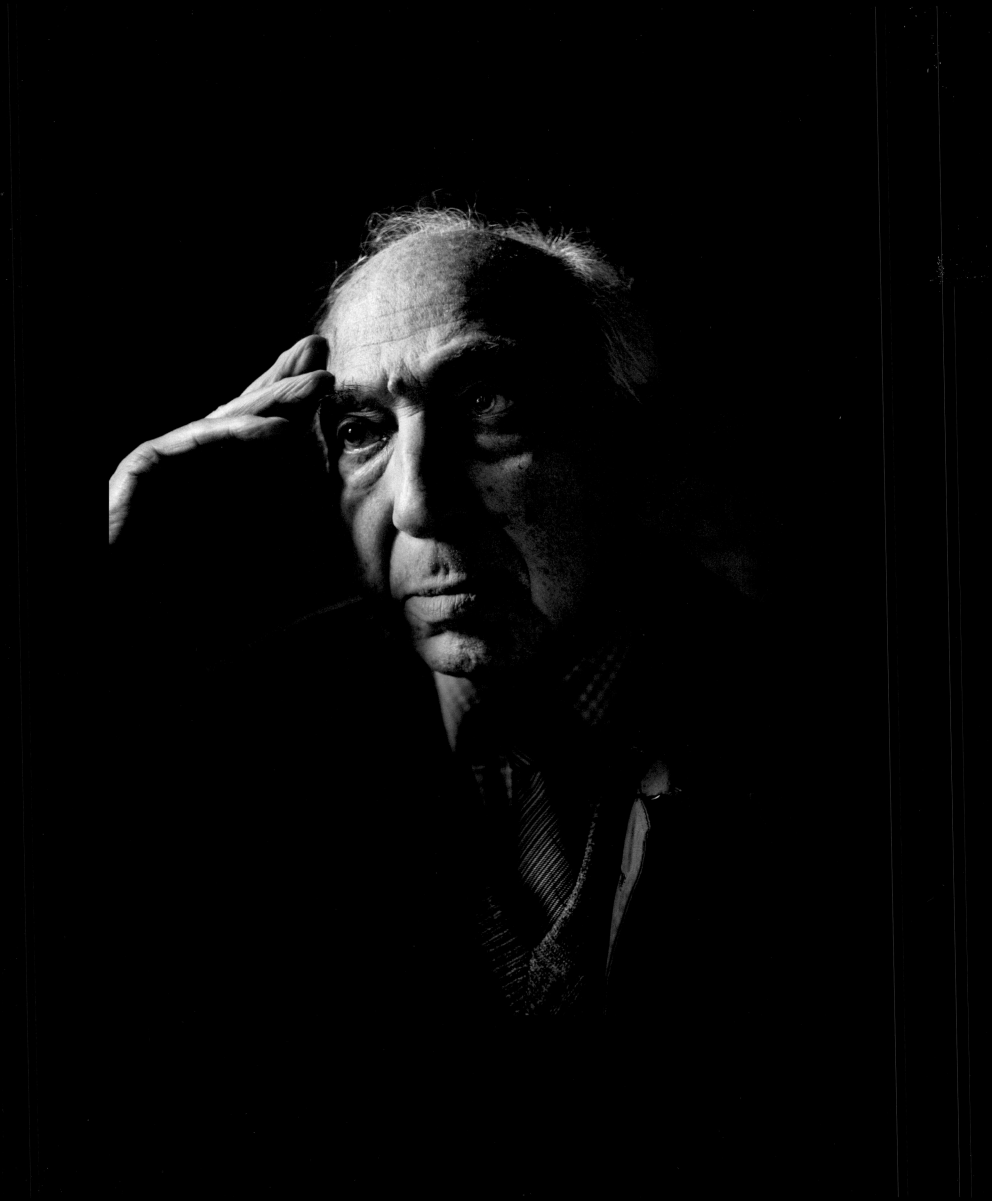

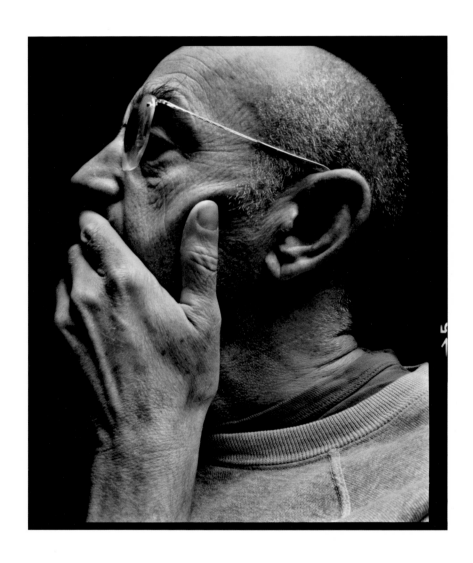

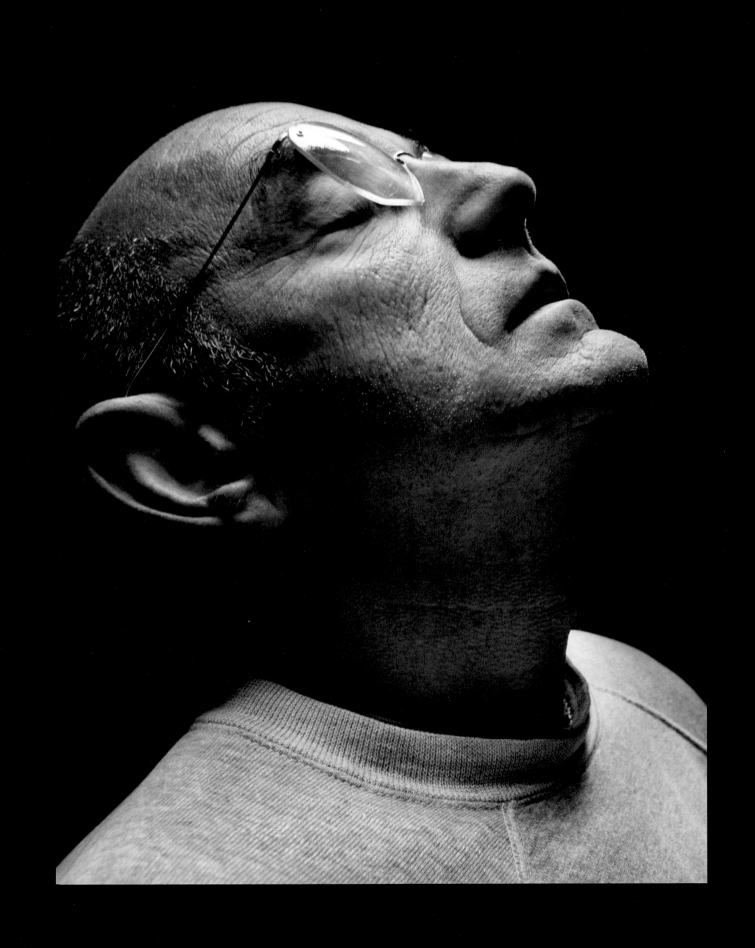

→ JEANLOUP SIEFF, PARIS, 1983

→ JACQUES HENRI LARTIGUE, PARIS, 1983

46　　•　　→　BRASSAÏ, PARIS, 1983

→ ROBERT DOISNEAU, PARIS, 1983

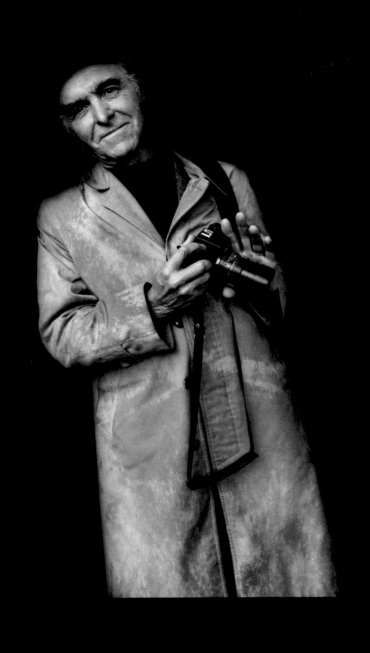

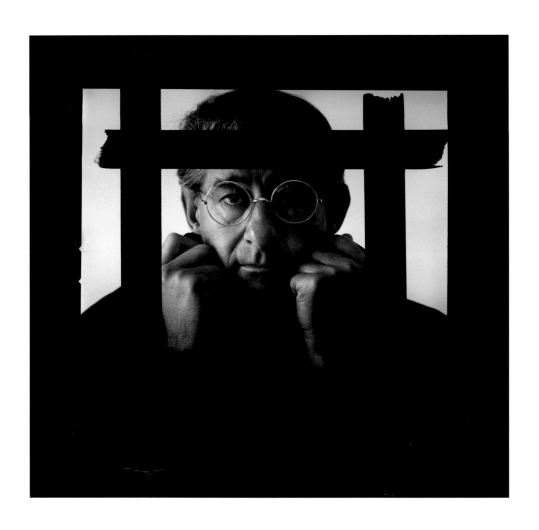

50    •    → HELMUT NEWTON, MONACO, 1983

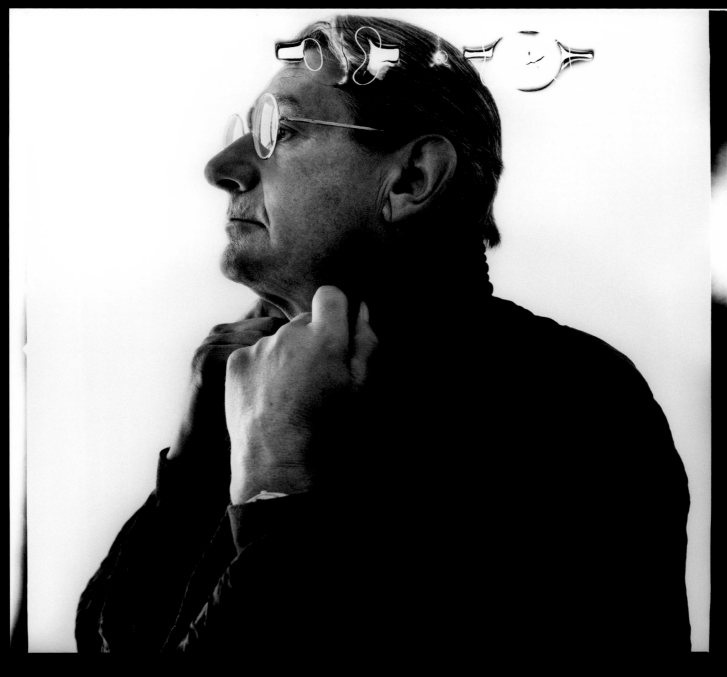

→ FRITZ KEMPE, HAMBURG, 1983

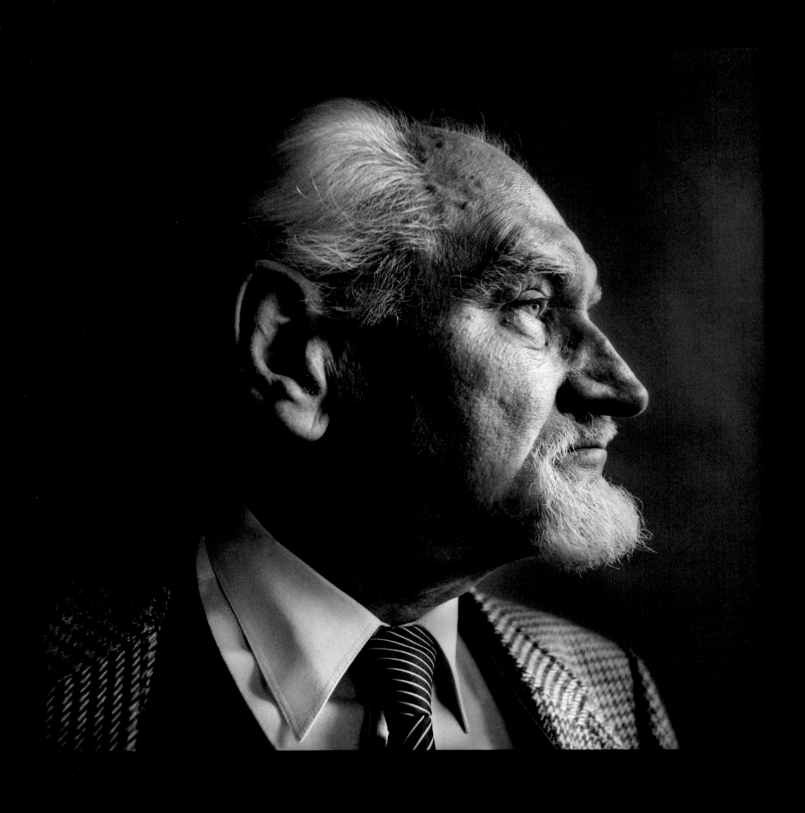

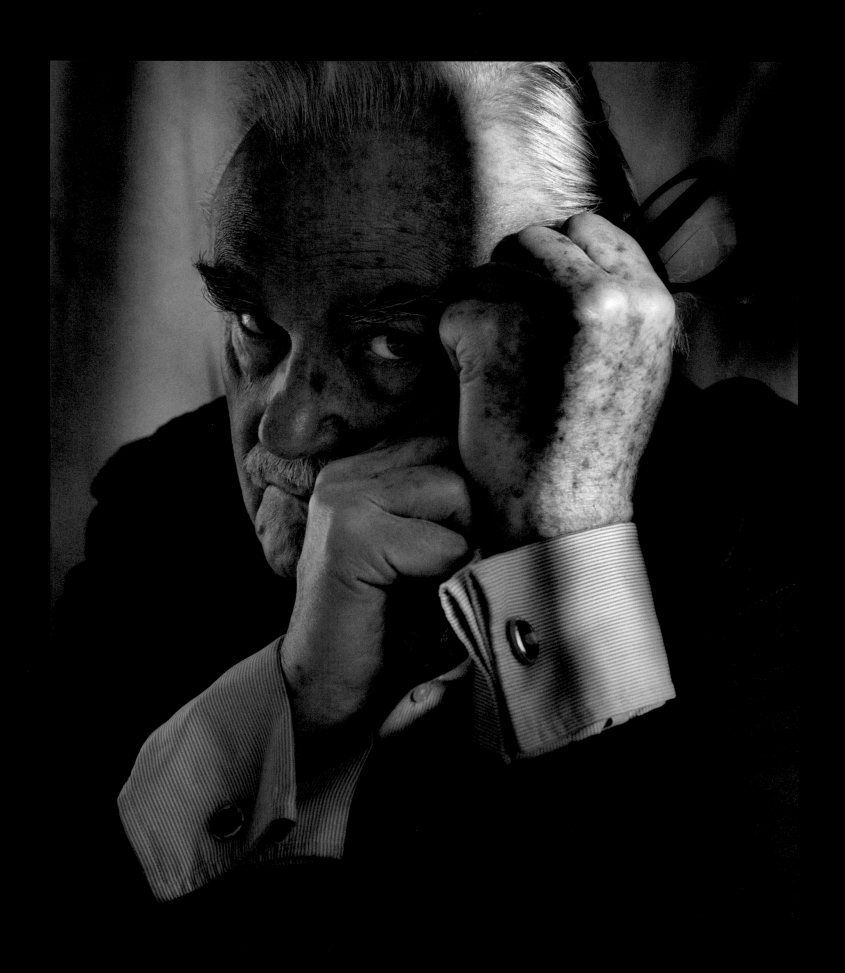

→ MARY ELLEN MARK, NEW YORK CITY, 2011

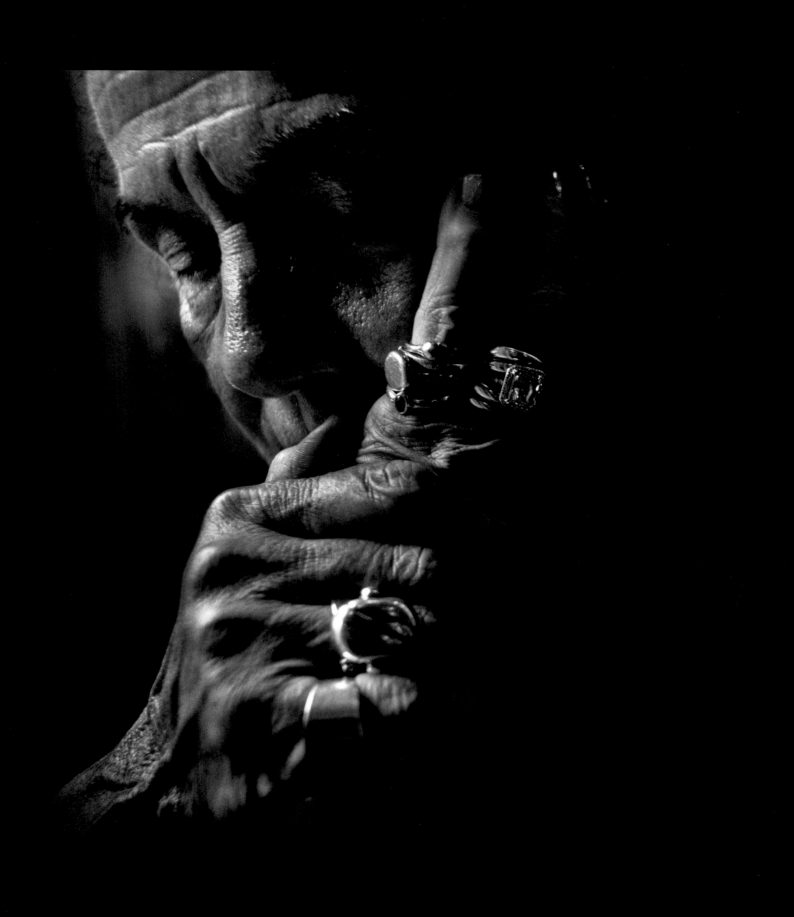

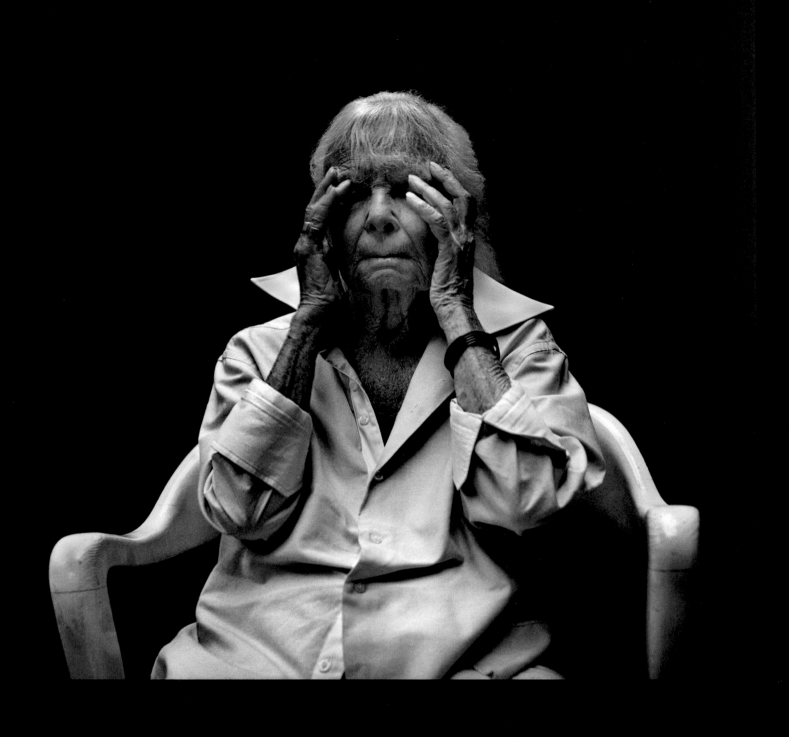

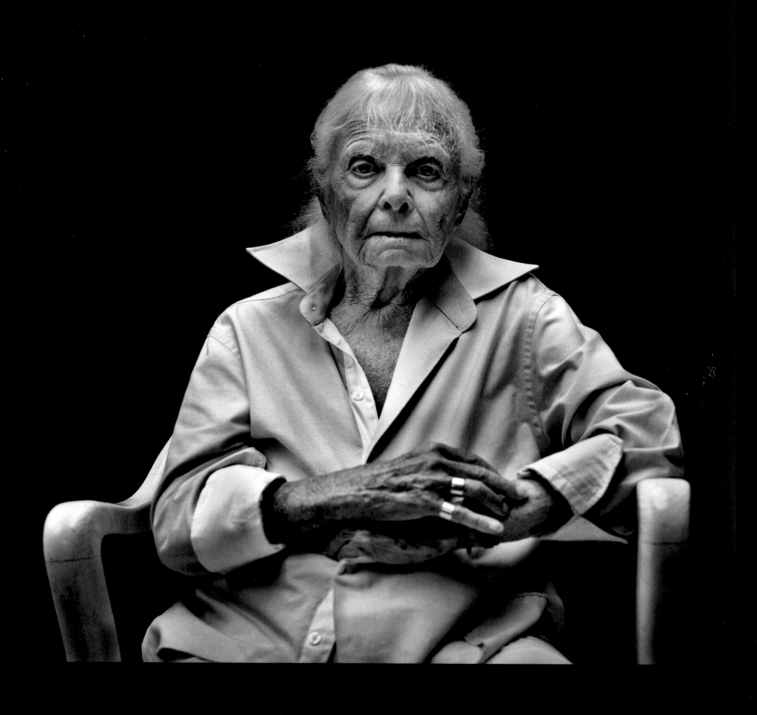

# A Moment.

→

・・・

Let me start by talking about passion. Not the kind that excites thirteen-year-old boys. Not the kind that makes men in their forties buy sports cars they can't afford, much less drive properly. I want to speak about passion that is rooted so deeply it is as difficult to reveal as it is to tell someone who you are in love with, that you are in love with them.

I speak of the delicacy, the fragility of a freshly hatched bird, of a seed that has just broken the surface of the earth. You may wonder why I speak about these things as if I were preparing you, the reader, for a cheap romance novel where the guy doesn't get the girl, but it is all okay, because the experience is of greater meaning. It is not. And I am not. I want to speak to you about passion.

When I first met Michael Somoroff, I was sitting at my desk in my gallery, the Feroz Gallery in Bonn. He called me to speak about a project he was working on at the time. The project was important, but assuming you, the reader, have not been a regular part of my life I will assume the project may not be important to you. Indeed it is not important to me in how the cloth of my experience with Michael Somoroff is woven. The fact is, he called. I answered. We spoke.

From that day, we have spoken often, and in depth. We have discussed the roots of what we strive for collectively and individually. We have pondered the meaning of the arts, of translation, of love, of vision and seeing. There has

been mention of perfect technique as a simple crutch, allowing true meaning to become visible. We have spoken about how growing up in a world filled with a higher level of vision and thought has influenced us both, indeed it has changed us both.

Michael and I grew up in the shadow of great photography. My life was filled by the works of fantastic photographers, painters, and critics. My father being Gerd Sander, the grandson of August Sander and one of the photography dealers who helped to create the photography market, I was constantly surrounded by the works of such greats as Josef Sudek, André Kertész, Lisette Model, and of course, August Sander. Michael's life was filled with great photographers, such as Arnold Newman, Andreas Feininger, Louis Faurer, and most important his father Ben Somoroff, from whom he learned the foundations of his skill.

Now consider comparing yourself to these giants. The bar is just plain high. And the shadow is long, often too long. It can drive most of us to hide behind

whatever we see as being big enough to shield us from our fear of failing to meet the standard we have set. And it will work long enough to either quietly suffocate the passion, or allow us a way to continue following the passion, like a buried seed breaks through the earth because it has to.

This is what I see in Michael. Despite every effort to suppress his passion it has remained, and thank God it has. This book represents the first time Michael has braved the public eye with his photography in a very, very long time. It is filled with images of photographers on the "wrong" side of a lens, and Michael on the right side of the lens. Most great photographers are blessed to be seen through how they see the world. This is a chance to see Michael in just that way. So I invite you to free yourself, for a few pages, of your daily concerns and see the world through the eyes of Michael Somoroff. Passionately.

JULIAN SANDER BONN, 2012

# ANDREAS FEININGER

18 EAST STREET
NEW YORK, N.Y. 10022
TEL: (212)633-4882

18 ELIZABETH LANE
NEW MILFORD, CT. 06776
TEL: (203)-354-8288

Herrn Michael Somoroff
Dorotheenstrasse 176
2000 Hamburg 60
Fed. Rep. Germany

June 27, 1985

Dear Michael,

I have just received your poster with my portrait, and
I must confess, it looks stunning. Congratulations!

Your accompanying letter, though difficult to read, was
likewise of great interest to me. It seems to me we
more or less share the same views, at least in principle
if not always in the form of execution. This, of course,
is probably due to our difference in age, I being more
tied to the past, you plunging ahead into the future.

I think we both agree that photography is a means of com-
munication -- the photographer, via his images, wants to
tell something to other people. To be successful in this
endeavour, two conditions must be fulfilled: the subject
matter must be meaningful, and the form of execution or
interpretation must not be beyond the understanding of
the audience for which the picture is intended.

I believe we photographers must not make the mistake of
many modern abstract artists who, though often highly ac-
claimed by the "experts," produce works which, to me, are
meaningless "Schmiererei." From what I see exhibited here
in the galleries on 57th Street and in Soho, apparently
everything goes, just as long as it is "abstract." But
I fail to see the significance of, say, the floor of a huge
exhibition hall covered evenly with several hundred large
brass cylinders of identical diameter and length, or the
ceiling of another gallery coverd from beginning to end
with some twohundred clear glass sheets, all hanging slightly
angled down in endless rows. Not to speak of huge paintings
which look as if somebody had used the canvas to clean cans
of different paints, or wiped the paint off an unsatis-
factory painting. There is no structure, no form, no pro-
portions or relationships between the different picture ele-
ments, only chaos. These paintings, which perhaps are in-
tended to interprete our present chaotic time, fail even
in this respect because they don't give us anything, don't
stimulate me or make me think; they are neither beautiful
in an abstract way, nor particularly ugly. They are simply
boring, a total waste of my time.

Over, please

Now, I have seen many photographs by young "experimental"
photographers who come damn close to this visual anarchy --
double- and triple-exposures and superimpositions, unsharp-
ness and camera-motion induced blur which, at least in my
opinion, didn't contribute anything to making the image more
meaningful or the subject more characteristic, poorly exe-
cuted or badly misplaced solarisations, and so on. And again,
as in painting, as long as these effects are "new," they will
be reproduced in camera magazines (which probably was the
reason why the photographer produced them), no matter how
absurd the impression.

Don't get me wrong -- I don't condemn any photo-technique, no
matter how strange or far-fetched. What I object to is the
indiscriminate use of such techniques merely because they are
unusual and therefore likely to draw attention. As a matter of
fact, I have extensively experimented with all of them (and
published many such images in my books New Paths in Photography
(American Photographic Publishing Co., Boston, 1939) and
Experimental Work (Amphoto, 1978). But I used these techniques
only because they were most likely to give me the results I
visualized, not because they were "strange."

As far as my present work is concerned, I have just put the
finishing touches to a 240-page monograph of my entire photo-
graphic work which will be published next year by Harry N.
Abrams -- the most prestigious art book publisher in America.
And I have great hopes that another book of mine, Design by
Nature, will be accepted for publication by the Sierra Club
in San Francisco.

Now I am going back to study and photograph the structural
forms of nature with special emphasis on the relationship bet-
ween function and form. Also, an exhibition of some very old
"experimental" and some very recent "straight" photographs by
me is presently running at the Daniel Wolf Gallery on 57 Street.

Enough for today. Keep in touch.

All the best -

Andreas

Paris 29.2.83

Dear Michael,

Thank you for the portrait,
I like it very much,
the right eye and the
are being the 2 most
important parts of a
photographer's personality!
Hope to see you next
time -

All my best

Henri C.

★ foto+film journal

»Ein Foto
soll etwas
über Dinge
aussagen,
die man
nicht kennt.«
Andreas
Feininger, ge-
boren 1906
in Paris

»Ich habe
den Franzo-
sen die Idee
von Paris
in Bildern
aufbewahrt.«
Brassaï
(1899 – 1984)

»Ich bin weder Fotograf noch Maler. Ich bin ein Einfänger.«
Jacques-Henri Lartigue, geboren 1894 in Paris

## „Who is Who"
## der
## Fotografie

Seit 1980
portraitiert der
Amerikaner
Michael Somoroff
prominente
Lichtbildner –
eine Art
Ahnengalerie

Wenn ein Gastwirt Gast wird,
dann ist das nur ein Sprachwitz.
Wenn jedoch ein Fotograf Fo-
tografen fotografiert, dann
kann, wenn er es gut macht, so
etwas herauskommen wie das,
was der Amerikaner Michael
Somoroff derzeit in der Ham-
burger PPS-Galerie präsentiert
– ein »Who's Who« der Foto-
grafie.

Der 1957 in New York gebo-
rene Somoroff ist für solche
Dokumentation erblich vorbe-
lastet. Sein Vater, der in diesem
Jahr 66jährig verstorben ist, gilt
neben Irving Penn als einer der
besten Still-life-Fotografen der
Welt. In seinem Hause ver-
kehrten all jene Kamera-Mei-
ster, die sein Sohn nun in einer
Art Prominenten-Galerie –
aus tiefster Bewunderung für
ihr Werk – abgelichtet hat.

1980 begann der heute 27jäh-
rige mit den ersten Aufnahmen
für die einmalige Fotoserie, die
von Andreas Feininger über
Art Kane bis zu Bert Stern und
Elliot Erwitt reicht. Dem viel-
fach ausgezeichneten Fotogra-
fen sind dabei eindrucksvolle,
vor allem aber seltene Porträts
gelungen, beispielsweise als er
die »Urväter der Fotografie«,
Lartigue und Brassaï – dessen
Porträt ist das letzte, das vor
seinem Tode gemacht wurde –
aufnahm.

Die insgesamt 30 großforma-
tigen Schwarzweiß-Fotografien
– sie werden erstmals außerhalb
der Vereinigten Staaten gezeigt
– machen Michael Somoroff
schon jetzt zu einem Fotogra-
fen, der mit einem Selbstpor-
trait in seine eigene Serie aufge-
nommen werden müßte.

228 stern

R. Doisneau

En un souvenir d'une journée de pluie
sur les quais de la Seine -

Quelle vous ma surprise de me trouver de ce
côté de l'objectif, c'est finalement toi
qu'a valable en compagnie de l'ami Somoroff -
En toute complicité amicale -

Robert Doisneau

## Helmut Newton

7th December.

Dear friend,
I want to thank you so much
for the stand and the reflector
bulbs of which will come in mightly
handy in L.A. (there off on the 26th
for 3 months) and to say that
the views point so great!!
Helmut says if any view equipment
doesn't work I can always use the
stand and learn to play the fiddle!
I'm very touched! Will let you know
how they work out. Heart knows when
but hope to visit you in Hamburg.

Best regards
Anne

Thank you for the
lovely print
Helmut N.

Pour mon jeune collègue
Michael Somoroff

bien
amicalement

Brassaï

# LE PARIS
# SECRET
# DES ANNÉES
# 30

## PAR BRASSAÏ

Paris, le 19 Octobre
1983.

GALLIMARD

Leslie Gill
A Classical Approach to Photography 1935-1958

LESLIE GILL
A CLASSICAL APPROACH TO PHOTOGRAPHY 1935-1958

Published by the New Orleans Museum of Art

Don't run out to get an 8x10 view camera!
love
michael

Frances McLaughlin-Gill 1983.

When the photographer Michael Somoroff invited me to contribute an essay for this book, it was a reunion, of sorts. I had last met Michael in 1979, only my second year in New York, and I was really just a neophyte in my field, as he was in his. The occasion was an exhibition of his vegetable pictures at the International Center of Photography, which Cornell Capa had organized. I recall an enthusiastic young photographer, grateful to be on the walls of the museum, and in the company of acknowledged masters. I also remember being curious as to the road he would take. Neither of us could have foreseen that he would end up as a much-sought-after commercial film director—though neither of us would have been surprised to find that he would never give up his love for the camera.

Michael went one way and I went another, and our paths only crossed again some thirty years later, when he offered me a chance to write about that early moment in our lives: the moment for him that marked a burst of creative work, and which resulted in the photographs in this book; the moment for me when I was fresh to the city and open to its photographic treasures (both its objects and its people). In fact I am privileged to have known many of Somoroff's subjects: André Kertész, Arnold Newman, Jacques Henri Lartigue, Elliott Erwitt, Ralph Gibson, Duane Michals, and Cornell Capa had all been my guests in Montreal in the early 1970s, where I ran a gallery. Later I worked at Capa's side in the early years of the International Center of Photography as the director of exhibitions. Andreas Feininger and Ernst Haas often dropped by, and I gleaned not a few pearls of wisdom from them. Meanwhile I worked closely with Horst P. Horst, first on an exhibition of the lifework of his friend and mentor, George Hoyningen-Huene, and later on his own. So Michael's invitation, coming some thirty years after our initial meeting, really did strike a chord: it would give me a chance to take a new "moment" to reflect back on a time that had been special for both of us.

Was this moment special in an objective, historical sense? As a discrete seven-year period, no. But if seen as a seven-year cross section from a larger time frame, yes. The period in question is that of late postwar photography, when institutions were being formed, a market was being created, a public was being educated, and a rather stand-offish art world was beginning to realize that it might have misjudged the upstart medium.

For the sake of focus, one might say that the period was bracketed by Edward Steichen's *The Family of Man*, held at the Museum of Modern Art in 1955, and John Szarkowski's *Photography Until Now*, held at MoMA in 1989. The former held that a photographer's job was to bear objective witness to the world; the latter that "most issues of importance cannot be photographed."[1]

Given the attention and respect accorded photography today—the many museums with serious programs and regularly record-breaking, sometimes even blockbuster exhibitions; the blue-chip galleries and auction houses with their sales of individual photographs in the millions of dollars; the schools and universities offering everything from degrees for photographers and curators to public workshops with "the masters"; the vast array of catalogues, books, and magazines; the fast-multiplying festivals and "Months of Photography"—it is hard to believe that only a few decades ago anyone contemplating a career in what is called rather awkwardly "art photography," as a photographer, curator, or dealer, would most likely be told to get his head examined.

On the other hand, for those who *were* willing to put their heads and hearts into the venture, there would be much in the way of rewards—provided that money wasn't anywhere near the top of the list. (An art dealer

in the early '70s, who might be tempted to try his luck with photography, would have taken note that a Diane Arbus print could be bought for $150 from the Witkin Gallery, netting a "profit" of $75 for the grateful gallery.)

Curiously, for the art photographers themselves, that lack of money was a badge of honor; it signalled to one's fellows, though perhaps not consciously, that one's motives were pure—art photography for art photography's sake. A virtue was made of a stark fact: namely, that the great majority of people wouldn't shell out cash for something they could cut out of a magazine and stick in a frame or buy for a pittance as a poster. Still, photographers had to earn a living somehow, and commercial assignments were always an option, though it was best not to brag about them if one wanted to wear the mantle of an artist. Memories were still fresh of Edward Steichen's fate; despite towering accomplishments as a young man, he had been banished from the sacrosanct domain of Art by Alfred Stieglitz and Paul Strand for daring to offer his services to industry—even worse, to the frivolous domain of fashion.[2] Photographers of the period could not easily avoid the quasi-religious aspect of the faith: no one had forgotten how the high priest, Ansel Adams, had accused Steichen of being the Antichrist! No, a safer route would be via small grants, teaching workshops, and government commissions, though these were hard to come by. It all added up to a pretty hand-to-mouth existence.

What then were the rewards, if not financial? The period in which Michael Somoroff made the portraits in this book (with one or two exceptions), 1977 to 1984, was one of great optimism, sometimes even of *evangelical* optimism, for the men and women who involved themselves in pursuing or promoting art photography. There was a feeling that photography was a medium that was yet to be recognized both for its past achievements

MICHAEL SOMOROFF ARRIVING AT THE ORIGINAL LOCATION ON FIFTH AVENUE, NYC OF THE INTERNATIONAL CENTER OF PHOTOGRAPHY FOR HIS FIRST MUSEUM OPENING: *THE VEGETABLE SERIES*, 1979    • • •

and its vast creative potential. This excitement went hand in hand with a strong sense of community, as Somoroff himself vividly recalls. As a twenty-year-old, he would, "just show up somewhere as a photographer and be embraced by other photographers."[3] In a very real sense, this community knew no bounds: there were one or two sympathetic souls in almost every country ready and eager to give visitors warm welcomes, arrange showings of their work in schools and modest galleries, slip their work into local festivals, or make introductions to sympathetic editors.[4]

Moreover, there was a sense of doing battle on behalf of the young art (one can take issue with the word *young*, of course, as the campaign had been going on for over a century, but there was this definite feeling of *youthfulness* to the medium, as distinct from the more venerable "fine arts" of painting and sculpture, seen by the new generation as senior citizens who really deserved to finish their days in a comfortable old folk's home). There was satisfaction to be gained in the cause of converting nonbelievers who persisted in regarding the medium as suitable for press, advertising, publicity, and other utilitarian purposes, but hardly as worthy of being exhibited on gallery and museum walls.

One problem that bedevilled believers and nonbelievers alike was semantic confusion (though this accurately reflected confused notions): What exactly *was* art photography? The public knew what an advertising photographer was, and what a photojournalist did, and if photographs had naked young girls in them, supine, with eyes closed, well, that might be Art, but someone who wandered the streets looking for odd juxtapositions, harassed pedestrians, or merely paint peeling off walls? It was hard to find words to say what this was, even by the photographers themselves. The public also knew what they *themselves* did with their cameras—they brought them on vacation and took them out at birthday parties and anniversaries. A small but not negligible percentage was even serious about it. A coterie of these enlightened amateurs joined camera clubs and subscribed to monthly magazines that went to great lengths to tell them what "artistic" meant, and how to achieve the perfect composition. The public also knew what "professional photography" meant—it meant commerce and industry in general, and in-as-much as it touched their lives directly, visits to respectable studios for graduation and wedding photographs. But did this all mean that the "serious" art photographer wasn't a professional? And if *the* art photographers defined themselves as serious, what did that say about the professionals, who were certainly serious enough to be raking in hundreds of thousands of dollars from satisfied clients? Michael Somoroff clearly recalls Helmut Newton complaining that "the art world wouldn't take him seriously because he was so successful commercially," and Richard Avedon getting "the cold shoulder from the art world," for similar reasons.[5] Of course it helped to have authoritative voices to tell people what to think. In the press release for Irving Penn's Museum of Modern Art show in 1975, curator John Szarkowski utterly dismissed the subject matter (cigarette butts) as "capricious and frankly inconsequential" while instructing viewers that "these photographs can be considered only as works of art."

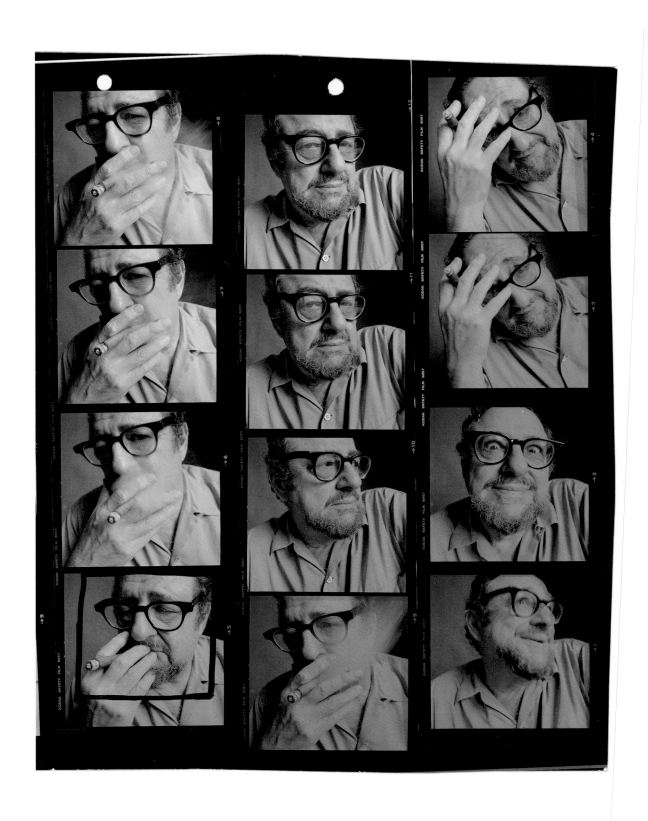

CONTACT SHEET OF THE ARNOLD NEWMAN SITTING, 1979    • • •

These questions about art went round and round, exasperating those who thought eyes and minds would be better engaged producing magnificent photographs. The art would, or should, take care of itself.

One of Somoroff's subjects, Arnold Newman, certainly felt this way. Newman often described himself as a "magazine photographer," which really meant something back then, in the heyday of *Life*, *Look*, the *Saturday Evening Post*, and *Holiday*. What Newman loved to do was make portraits of artists, and so was pigeonholed (understandably) as a portrait photographer (indeed, in recognition of his particular style, as "the father of *environmental* portraiture"). But he was vexed by both labels—the word *portrait* obscured the fact that his pictures were first and foremost good photographs, and as for the word *environmental*, Newman complained that "it was inflicted on me."[6] He yearned to be recognized simply as a photographer, and to have his photographs judged as good, sometimes great, *pictures*, in this most modern medium.

There was another diffuse threat felt by art photographers of the time. It was difficult to articulate, yet uncomfortably close by, in the form of a rival body that had its own fixed ideas about, and uses for, photography. These ideas were very limited, even small-minded, but they were still imperious. They were to be found in the nearby field of contemporary art. In the absence of visitors to their remote sites, Land artists like Robert Smithson and Michael Heizer took photographs as evidence. The Pop artists, like Andy Warhol, Richard Hamilton, James Rosenquist, and Claes Oldenburg, used photographs as rough and ready source material, given value only via transformation, just as artists had done since the 1920s in their collages and montages. Many contemporary artists also made their own photographs, but purely as documentation, records of their artworks suitable for reproduction; they were seen as having no value beyond this purely utilitarian function. The walls of the great museums and most prestigious galleries were still reserved for what by common cultural consent was *real* art: painting and sculpture. Photography, by comparison, retained a decidedly inferior status as an art form, or was considered to have none at all. It was not unlike the thinly disguised contempt colonial powers felt for their colonies.

In a nutshell, the semantic turbulence tells us that the society itself hadn't quite come to grips with photography. All of its strands *were* vital (and remain so today), even if they had to define themselves by what they were *not*. But if the issues were constantly irritating to those with sure ideas of photography's worth, they nevertheless made for a vibrant culture. The uncertainties stimulated thought about what the medium could and should be. Should a gallery of photography look and act like a painting gallery? Should a museum collect photographs as it did paintings? What was an original—the negative or a print? Should exhibitions of photographs mimic those of paintings? Should prints be produced in limited editions, and if so, in editions of what size? (Most dealers, knowing the value of rarity, wanted limited editions; most photographers thought the concept was absurd, pointing out that a negative can produce one hundred thousand prints without degradation, as easily as it can produce five.) And what about those new color photographs that the younger

generation was so keen on? Surely color was the realm of garish advertising—didn't photography's nobility rest on its black-and-white purity? And so on. People had no difficulty in distinguishing a house painter from a true artist, but were not so sure when it came to appreciating the distinction between a photographer glamorizing Marlboro cigarettes and an Irving Penn glamorizing cigarette butts.

While the period covered by Somoroff was one of great hope for the medium, and a genuine openness to new directions (I think of Art Kane here, showing up at Somoroff's studio full of enthusiasm for the new road taken by Robert Mapplethorpe with his male nudes), there were far fewer opportunities for the men and women we see in Somoroff's portraits than there are today for their descendants (though conversely there is much more competition for those increased resources). Fewer galleries (and those that were, were more of-

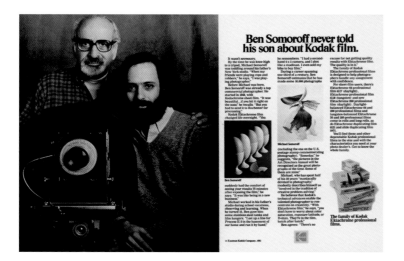

ten affairs of the heart than rational business models); far fewer museums with significant programs; only a handful of magazines; and very few publishers ready to risk the enormous cost of high-quality books. As for aspiring curators, schools of advanced learning were almost nonexistent, and jobs for graduates few and far between. The few graduates that there were had to create their own positions (and sometimes departments), elbowing their way into museums where painting, drawing, sculpture, and design made way for them only grudgingly. (A classic compromise was a Department of Prints, Drawings, *and* Photographs.) What the photographers of the period did have, along with that sense of community and shared purpose, was a feeling of *family*, i.e., of following in the footsteps of pioneering forefathers. For Michael Somoroff, it was quite literal: his father Ben was a highly successful commercial photographer, and as Somoroff tells us in this book, photographers were constant visitors to the home and the studio. The great art director-turned-photographer, Henry Wolf, was even Michael's godfather. Beyond this immediate "family" there was the great tradition of American photography. Most serious young photographers were conscious of a range of accomplishments of their countrymen: the f/64 photographers, particularly Edward Weston; the FSA photographers, particularly Walker Evans; and further back, Alfred Stieglitz and his pioneering circle, particularly Paul Strand. Young New Yorkers also knew, or were getting to know, some of the great European masters, either those who had migrated to the U.S. or had large enough reputations to attract American institutions.

However, we would do well to remember that the broad picture we have of global photography today (still wanting in areas, but certainly much expanded on the view from the mid-70s) was generally ethnocentric (Western European and American). Czech, Hungarian, and Polish photography, rich in history, were only sketchily

appreciated, Japanese and South American photography was only beginning to be known, Chinese and African photography, not at all. (I remember going to a lecture in Europe, in the mid-70s, where an American professor outlined the history of twentieth-century photography, from Stieglitz to the present, without a single reference to a non-American figure.)

The fact of the matter was that the Americans were setting the agenda, with New York's Museum of Modern Art (in the person of John Szarkowski) occupying what curator Chris Phillips has called "the judgment seat of photography."[7] All roads *did* lead to New York in the '70s and '80s. And though he did not quite know it, Michael Somoroff stood at the crossroads.

But he must have *felt* it, judging from the constant stream of photographers, young and old, to the city. He could not have been unaware of the heavy European content of his subject matter. Brassaï, André Kertész, and Cornell Capa were from Hungary; Ernst Haas was from Austria; Horst, Fritz Kempe, Helmut Newton (via Australia and France), Herman Landshoff, and F.C. Gundlach were from Germany; Andreas Feininger, Jacques Henri Lartigue, and Jeanloup Sieff were from France. Art Kane's roots were in Poland (Arthur Kanofsky), and Arnold Newman's grandparents were born in Russia (or Poland), and had spent time in Germany. Michael Somoroff's own father, Ben, was a first-generation immigrant from Belarus. And Elliott Erwitt, though American, was born in Paris of Russian parents, and brought up in Milan. And although Michael Somoroff did travel to Europe for some of his portraits, all of his subjects also travelled back and forth to America with ease. (When Somoroff went to see Jeanloup Sieff in Paris, he was given an exceptionally warm welcome, due, he later realized, to the help his own father had given Sieff years earlier in New York.)

The war, and the terrible events leading up to it, largely explains how and why the New York scene was so heavily European, along with a disproportionate percentage of Jews. Kertész came to the U.S. in 1936, Horst in 1937, while Feininger got out of Paris in the nick of time—1939. Landshoff managed to escape France in 1941. Beyond the necessity of sheer survival for some, there was also the allure of the great city, receptive as always to talent, from others. Haas was still living in his native Austria when he received an invitation from *Life* magazine to come and work for them. He declined, but became a regular visitor to the U.S. in the 1950s, and finally moved permanently to New York in 1965. Other émigrés were feted almost immediately. Shortly after his arrival in 1936, Kertész was invited to show at the PM Gallery in Manhattan, and was included in a landmark MoMA survey show organized by Beaumont Newhall the following year.

SOMOROFF'S SEQUENCE STUDY OF ANDRÉ KERTÉSZ, 1982   • • •

For those interested in furthering photography, the world (seen as American and European) was a small place. A few big cities had small galleries, and usually only one or two. Even the grandest metropolis (London, Paris) had handfuls of professionals driving photography forward, rather than the hundreds or thousands you would find today. Curators, dealers, and historians of photography were largely self-taught, and came from other fields; Szarkowski, the eminent curator at MoMA, was a photographer, not an art historian. Robert Delpire, the great French publisher, was trained as a physician. The British Colin Osman used the proceeds of the aptly named Coo Press, which specialized in racing pigeons, to finance the seminal magazine *Creative Camera*, while a journalist, Romeo Martinez, took over the reins of the influential Swiss magazine, *Camera*, in 1956.[8] People seemed to fall into photography, or to quote Michael Somoroff's father, Ben, "bump into it," as he himself had done.

This is not the place for anything but a cursory sketch of how the landscape of photography was transformed during the postwar years, but to cite a few notable landmarks: Szarkowski's arrival at MoMA in 1962; the founding of the Society for Photographic Education, with its magazine, *Exposure*, in the same year; the opening of Galerie Delpire in Paris in 1963; the founding of the festival, Les Rencontres d'Arles, in 1968; and the founding of the Visual Studies Workshop in Rochester, New York, in 1969, a year that also saw the opening of the Witkin Gallery in New York City; the first publications of Lustrum Press in 1970; the opening of the Photographers' Gallery in London ("gallery" is misleading; it was much more of a center), and Light Gallery in New York in 1971; the founding of the Center for Creative Photography in Tucson, Arizona, and of the International Center of Photography, in New York, in 1975; the publication in 1977, of Susan Sontag's *On Photography*; and the great taking-stock-of-photography, the city-wide festival, Venezia La Fotografia, in 1979. A year earlier, *Time* magazine reviewed Szarkowski's *Mirrors and Windows*, concluding, "In the past ten years photography has swept, as it were, from the magazine to the museum. There is no debate left on whether photography is an art; it is universally accepted as such."[9]

Let's take a snapshot of any one year, perhaps 1980, which lands us smack in the middle of Somoroff's project. What were his subjects up to? Elliott Erwitt, Cornell Capa, Arnold Newman, Andreas Feininger, André Kertész, and Ernst Haas were being shown in *Photography of the 1950s*, curated by Helen Gee at the International Center of Photography; Robert Doisneau was showing in *The Imaginary Photo Museum* at the Kunsthalle in Cologne, and publishing his *Ballade pour violoncelle et chambre noir* with coauthor Maurice Baquet in Paris; Andreas Feininger was having a one-man show at Southwest Texas State University and participating in *Avant-garde Photography in Germany, 1919–1939*, at the San Francisco Museum of Modern Art. Ralph Gibson was showing in a slew of galleries across Europe and the U.S., from Castelli Graphics in New York, to the Kunstmuseum in Düsseldorf, with stops at galleries in Cardiff, Hamburg, Rome, and London. Ernst Haas was included in a major survey, *Photography: Art and Use*, at the Museum of Art in São Paulo, and back in New York, picked up an award from the Art Directors Club. Horst P. Horst was showing at the Zabriskie Gallery in Paris and celebrating a retrospective of his friend and mentor, George Hoyningen-Huene at ICP in New

York; Fritz Kempe was showing at F.C. Gundlach's space in Hamburg. Arnold Newman had shows at Galerie Creatis in Paris and Light Gallery in New York, while overseeing publication of his *Artists: Four Decades*, while Helmut Newton was completing his Big Nudes series, published the following year, and showing at the G. Ray Hawkins Gallery in Los Angeles. André Kertész was showing at the Galerie Agathe Gaillard in Paris while being honored with a Medaille de la Ville de Paris, and was exhibiting at the University of Salford in the U.K. In Paris also, Jacques Henri Lartigue was feted with a large-scale retrospective at the Grand Palais, and Brassaï was publishing *Revelation: Letters from Brassaï to His Parents, 1920 to 1940*. And almost all of the photographers found regular support from the big magazines: *Vogue* and *American Photographer* each showed ten of them; *Life* and *Harper's Bazaar* showed nine apiece, *Look* published seven, and so on. This is by no means a complete inventory, but it at least provides a flavor of the time.

And where was Michael Somoroff, precisely, in 1980? He'd flown off to Germany, where he would stay for the year, determined to get out from the shadow of his highly successful father.[10]

One could take any of the above and trace the connections, nationally and internationally, of a vigorous, growing network of individuals and institutions (though that word implies a solidity they did not all have, as the Venice project makes clear; it had been hoped that it would become a biannual event). The galleries in New York, for example, fed galleries further afield, finding that they made as high as fifty percent of their sales to other galleries in the U.S. and Canada. The centers in the big cities soon connected with each other, and began to exchange ideas and exhibitions. University studies proliferated. Graduates of the Visual Studies Workshop in Rochester went on to run collections, and indeed, institutions on both sides of the Atlantic.

French historian Gilles Mora takes 1978 as the moment that American photography appeared "at the summit of its glory and of its certitudes,"[11] and if the date is a touch arbitrary, and the statement is even debatable, Mora does put his finger on the strong, confident current that pervaded the American scene at the time, and on which the young Somoroff could only have been swept along. By 1983, when Somoroff's work was finished, or rather put aside, another critic, Abigail Solomon-Godeau, could write, ". . . the great cooperative effort had worked . . . all that was first set out in its mid-nineteenth century agenda: general recognition as an art form, a place in the museum, a market (however erratic), a patrimonial lineage, an acknowledged canon."[12] Whether by chance or intent, Michael Somoroff had picked his moment well.

**WILLIAM A. EWING**  LAUSANNE, 2012

Notes

1. The quote is drawn from a review of the exhibition, *Mirrors and Windows*, curated by John Szarkowski at the Museum of Modern Art, New York, which appeared in *Time* magazine on August 7, 1978. But the words stand equally for the position he took in *Photography Until Now*, which took place in 1989.

2. Steichen was not the first fashion photographer, but he eclipsed the earlier efforts of Baron Adolph de Meyer. Steichen's role as head photographer at the Condé Nast magazines, *Vogue* and *Vanity Fair*, lasted from 1923 to 1939, during which time he was the highest paid photographer in the world. His willingness to devote himself to commerce earned him the disdain of many, but he replied to his critics with the argument that the best art of any epoch was, in one form or another, commissioned.

3. All quotations by Michael Somoroff in this text are taken from an unpublished interview that curator Diana Edkins conducted with him in 2011.

4. Many institutions that were founded in this period were begun by photographers frustrated with the lack of opportunities. For example, Cornell Capa founded the International Center of Photography, in 1975, and Lucien Clergue, was one of the founders of the annual festival, Les Rencontres d'Arles, first held in 1968. The pattern continues to this day.

5. This was after Avedon's big success, at least in the New York fashion world, of his exhibition at the Metropolitan Museum of Art, New York, in 1978.

6. From an extensive interview with Newman by curator Will Stapp at Princeton's Institute for Advanced Studies in 1991. Unpublished, the transcript is located at the Harry Ransom Center at the University of Texas, Austin.

7. Christopher Phillips, "The Judgement Seat of Photography," *October*, No. 22, fall 1982.

8. Romeo Martinez was succeeded in 1965 by the American Allan Porter, who remained at the magazine until 1981. Porter made the magazine one of the most influential publications of its era.

9. *Time*, "Art: Mirrors and Windows," August 7, 1978.

10. Though Somoroff admits that the decision may not have been entirely a conscious one.

11. Gilles Mora, *La photographie américaine, 1958–1981*. Paris: Seuil, 2007, p. 127.

12. Abigail Solomon-Godeau, quoted in Vangelis Athanassopoulos, "History of Photography: The 1980s," *Encyclopedia of Twentieth-Century Photography*, ed. Lynne Warren. Routledge: New York, 2006.

. . .

The photographs in this book portray *a moment.*

They were never intended for publication. They are very personal; a kind of journal that looks back on my beginnings and others' endings. They were taken innocently, when I was an apprentice in the truest sense, without an agenda. There was never a book or a project in mind. As a matter of fact, this body of pictures lay mostly forgotten for what is now the better part of thirty-five years. These images were a labor of love, an *homage* to my teachers, friends, and mentors. And, they are my roots, roots that are firmly grounded in the history of photography; that is *my* history. In a sense, they are a confession, an opening up of what matters to me most. . . . Beyond words, they are landmarks in eternity, the passing of an era, and the passage of my life. They are very intimate. They are where I come from and the core of who I am.

To be clear, first and foremost . . .

*I am a photographer.*

CLOCKWISE FROM TOP: HORST ON *VOGUE* ASSIGNMENT, 1980; SOMOROFF SHOOTING HORST, 1980; SOMOROFF SHOOTING LILLIAN BASSMAN, 2011; SOMOROFF LOADING CAMERA AS HORST WATCHES, 1980; SOMOROFF SHOOTING LILLIAN BASSMAN, 2011; MIDDLE IMAGE: SOMOROFF IN PARIS ON HIS WAY TO MEET LARTIGUE, 1983

More than depictions of my various subjects, these images represent an autobiographical instant, a beginning, and reverence for my roots, or rather, for where we all come from. They are not only portraits of my heroes, they are a portrait of a time[1], almost completely forgotten now, some thirty-five years later, when photography was coming into its own after the better part of a century of struggling to be honored as a legitimate artistic medium. Little did I know when I innocently sought to photograph so many of my champions, that analogue photography was in its death throes, virtually about to be replaced by electronics. With that change there would come a huge metamorphosis in the way we see the world and ourselves. Images would proliferate in our daily lives with an immediacy and accessibility never before seen by any civilization. It is a velocity that has been the catalyst for a kind of cultural attention deficit that is slowly wearing away at our collective possession of wisdom, and replacing it with endless and mostly worthless, information. As a result, our collective experience of Truth and geography has forever changed. The universe would somehow lean toward a special existential democracy—far away would become local, closed societies would become open ones, "limited" would become infinite.

We are still transitioning. It is impossible to predict where the current revolution in the psychology of our imaging will finally end. What is sure is that in the thirty-five years since I executed most of the portraits in this book the world has become a dramatically different place. The images in this monograph comprise an inadvertent portrait of a particular moment in the history of our culture.

This book is rooted in an analogue way of seeing the world, when life was slower and progress was more metered. The power of photography is its uncanny ability to express the picture-taker's vision of things on a subjective level and society's self-image on a collective level. It is the ultimate reality-creation device. It can be argued effectively that we are the way we see ourselves. Crucial to that process of collective self-definition was the invention of photography. We are pattern seekers and we do it through images—we see first. Correspondingly, as visual beings, we create a visual culture and the method and technology of our image making is literally our consciousness, i.e., our process of perceiving the world.

The photography I was born into was challenging, painstaking even. It was not a given that one would end up with an image at all, simply because one snapped a picture. As a matter of fact, the term "snapped" was a marketing device to convince the public that even they could do it. . . . The simple fact was mostly, they could not. When I wandered through my father's studio as a precocious three-year-old, the fastest color film was half as sensitive as the lowest setting on a digital camera today.[2] Dr. Land had yet to flood the world with instant pictures and the average exposure time in the studio, under a five-thousand-watt Klieg light was ten seconds! When my mother, a famous fashion model,[3] was photographed for the fur catalogues each season, the productions took place on the salt flats of Arizona because the brightest sunlight was needed to expose the fine texture of the dark minks on the negative. The temperatures were sweltering and the models would routinely faint, requiring a full-time handler allocated just to catching them before they hit the ground. This was "modern" photography.

How long ago this all was and yet it was the world I knew as a child. I remember vividly the huge breakthrough of the Kodak instamatic—35mm plastic cartridge cameras aimed at making photography accessible to everyone. Fast, then, meant rushing your exposed instamatic cartridge to the drug store to be processed, waiting three days—just enough time to develop a peak yearning to see the images one had captured—often only to discover to one's extreme disappointment that there had not been enough light in a given setting to even impress a single image on the roll of twelve-exposure film. This was "cutting-edge" technology.

In those days one actually needed a professional photographer to securely memorialize the important events of one's life because it was the only way to guarantee that there would be any images on the film to later commune with. To illustrate this, let me add that my brother asked me to photograph his wedding, as I was a young, aspiring photographer at fourteen. The result is that there are no pictures of his wedding!

Picture making was not a given. As a result, our vision of the world, our experience of it, was also not presumed or taken for granted as it is today. Yesterday's vision of the world was far more local, slower—there was an assumption that time, often a lot of time, was needed to do anything worthwhile. The consequence of this worldview was that we invested ourselves more faithfully in the process of things, knowing in our hearts that the results were to some extent beyond our control. In a certain way maybe we were humbler without even realizing it. We were certainly less distracted.

One assumed that the achievement of true quality as it pertained to a particular thing required an informed process, which took time. This meant there was a fundamentally different respect for time because we related it to the accumulation of knowledge and experience as a starting point for any worthwhile endeavor. Then, more time had to be invested toward analysis and mastery of craft—the management of the facts, both material and spiritual. Critical decisions were made that sometimes led to high quality outcomes. More often, and maybe more important, critical thinking was a process—one that always led to more experimentation. Generally speaking, it was a world where the destination was presumed to be a vital expression of the journey. There is no doubt in my mind that some of the dramatically different consciousness of that era was rooted in our experience of our media and the primary media of that era was photography. As Marshall McLuhan famously put it, "the message is the medium." And so it was.

In the period that the images in this book were created, a photograph was assumed to be inherently truthful. That whole idea seems absurd now but it was hard to convincingly change a photograph then. It took a lot of time and effort, often at a great expense. Retouching was an art. This was one of the main reasons commercial photography was so lucrative. One went to a good photographer because he or she could do it all "in camera" and avoid any retouching. Yes, the good ones could do it all before the click of the shutter.[4] This required a very high level of expertise and literally became the basis for the assumption that the "perfect" image could be created masterfully through a rigorous commitment to the craft and circumstance; craft that

took years to learn and required a master to teach. Circumstances that required the perseverance to hang around long enough and wait for fate to play its hand.

It seems we have mostly forgotten the etymology of the term "masterpiece," a term so rooted in the tempo of that era that it was taken for granted. Maybe that's why we have forgotten its origin and it appears we create fewer of them now. . . .

The masterpiece was part of a long, deliberate tradition of wisdom being handed down from one generation to another. Masterpieces represented a sluggish procession upward in the hierarchy of the life of the apprentice toward master-hood, a kind of artistic coming of age when the student would create his or her thesis piece, i.e., a "master-piece" upon which to be judged by his or her peers. It was a work that presumed innovation on the shoulders of a previous generation, in order to be accepted into the fraternity of future masters. This was the system of preparation not only into adulthood, but it was what becoming a real professional who had serious control over his or her craft, thus allowing for extensive artistic freedom, was all about.

It was an arduous course which guaranteed that once one had arrived, one had true knowledge at one's disposal as a tool toward future creations. Most important, it resulted in the initiation of many of the great artists pictured here into that age via a masterpiece or pieces for that matter, and helps to explain much of the rich abundance of truly great photography created during the twentieth century. This apprentice system was still a given when the images in this book were created. It was the system that my father Ben Somoroff, Irving Penn, Richard Avedon, Louis Faurer, Arnold Newman, and others were indoctrinated into under the supervision of Alexey Brodovitch and other masters.

It was the obstacle course I was born into and the preparatory program I cut my teeth on.

The innovations associated with this apprentice system and the hard-earned suppository of knowledge that it was invested with became a part of our collective resource for the progress of imagery that our society so fundamentally depends on. This reservoir of accumulated image experience was to become the whole basis of ideas behind the algorithms that inform technologies like Photoshop and 3-D animation software such as Maya. Ultimately they are extensions of it.

One of the results of all this and our enormous intellectual and spiritual investment was that we deeply believed photography. We also assumed a certain kind of communion, which was the only way to make a meaningful picture—human contact was mandated, not optional. Photography required humanity to have power. It was always somehow intimate. Call it the decisive moment or what you will, but getting "in there" as Brassaï said to me, and being a part of life unfolding, close to it, exposed, and vulnerable, were absolute requirements for great photography—and still are.[5] It was not virtual in any sense. On the contrary, it was often more real than reality. You could lose your life and might even indeed choose to sacrifice it, for a shot at capturing a great image.

Like today, we experience the "world" through pictures. Unlike today, for most people back then, world events were not events at all; rather, they were photographic images. This was the fundamental allure of photography, it was reality. Collectively, my generation went to the moon, we experienced far-off wars, we traveled, built postwar Europe—all thanks to the camera. We assumed our pictures were real events. It's all we had as a means to connect with one another, to conquer distances that were otherwise insurmountable. Our pictures were our social connection in the way the Internet is today. We built economies, played politics, both private and public, on the basis of that assumption. The images we created and put ourselves in through photography were real. We have mostly forgotten that this was exactly why it was so debated whether photography was an art.[6] Photography was too documentary to be considered artistic by most. Unlike today, we were not drowning in our images, i.e., in information, devoured by too many choices. I would like to suggest that we see the results before us of this flood, ours is a world far less stable and predictable—markets up, markets down. It's all connected with our image making.

I could go on but the effects of our cultural "evolution" into the digital age have been well explored. What I simply want to convey is that the pictures in this book, first of all, represent an age that is already long gone. It slipped away while we were preoccupied. It is an era so distant from us now, that I feel compelled to qualify this project because every assumption regarding the world we live in today needs to be reexamined and re-contextualized in order to fully appreciate the images here. Keep in mind while perusing these pages that the click you hear when you take a picture now is a virtual one, not a mechanical by-product of turning gears and active springs. It is an expression of cultural survival, not unlike the unnecessary curtain in a movie theater, a survivor from long ago. Alas, we are so used to that sound and to the mechanical language that helped us feel safe in our view of reality for more than a century, that we have included it in, and given honor to, the security we derive by synthesizing this nostalgic, yet now irrelevant technology, into our current inventions. It is no wonder that the "homecoming" feels hollow.

This is a book largely about a time when we were more careful. This is a book about the twilight of a medium we were addicted to and we used collectively to invent the world with. This book is about some of the people who invested their lives in the progress of our collective consciousness through images. Once, we waited impatiently each week for photo magazines like *Life* and *Look* to show up in our post boxes so that we might participate in the world rather than logging on. But, as we know, all that's changed. This book is about the beginning of that change as experienced through the eyes of the master image-makers of the day. It was a change rooted less in our technologies than one might think, and more in the way we saw things suddenly in response to their pictures. Last, but not least, this is certainly a portrait of a young man's passion and curiosity, his longing to become something and play a role in the world. It is about my journey to make a contribution to the world and to photography, ever my first love.

This is a book about those who came before me and on whose shoulders I stand. . . .

The period during which I took these pictures was a very special time indeed. . . . Who knew?

• • •

Often the best things come inadvertently. My doing portraits began innocently. Having grown up, in and out, of my father's studio, still life photography was very familiar to me. It was my father's specialization. The studio at 421 East Fifty-fourth Street in New York City was my never-never land, my refuge from what was mostly a painful childhood. I would yearn to visit, spending hours downstairs in the prop room and darkrooms. I

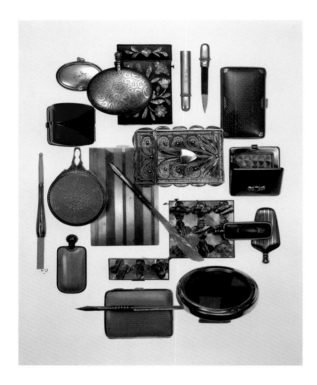

even can vividly remember the smell of the studio—a certain acidic odor; somehow a slight smell of hypo salt found its way upstairs into the lounge and wafted across the barn wood siding my father had recovered from some editorial project. I would wander up and down the painted gray staircase of the building, in and out of neighbors' studios, unannounced but always welcome. The great fashion photographer John Rawlings[7] was on the ground floor, with Ben Rose upstairs. Sol Mednick was there, too, and Louis Faurer would shoot there occasionally using someone's studio as he was often back and forth between Paris and New York then, when he wasn't on some street corner all night with Robert Frank in Times Square or by the East River—a stone's throw from the studio.

I had my first kiss in that studio. . . .

I idolized my father. As a child my favorite game before I was even four years of age was "studio." Much to my mother's chagrin, I would pull out all the extension cords around the house and scatter them over the floor of my playroom in Great Neck, Long Island. It was a wonderful house. My "playroom" was large and airy, encased in floor-to-ceiling windows that overlooked a brick terrace and a large private backyard. One of my fondest memories is of a toy camera my father made for me out of a milk carton and a toilet paper tube. On one side he punctured a hole for the tube; on the other, he cut a rectangular hole so that I could peer through the tube as if it were a lens. I spent many joyful hours playing "photography" and trying to be like Dad in that playroom.

It was a real gift whenever I could accompany my father to the studio on a weekend when he was demanded upon to complete an assignment against a deadline. Where, I am sure, most children's memories of their fathers are rooted in family vacations or holiday events, most of my childhood memories of my father take place at the studio (except for occasional baseball games with the Phillies and Yankees). I was so happy to be with him there, supplying an extra set of hands under the enlarger or lugging cable. I enjoyed being close

to him—taking an occasional break with everyone for pizza (still one of my favorites) and a dessert of halvah, a Middle Eastern sesame seed candy, surplus from his past life in the Jewish neighborhood of south Philly. Even food breaks were about photography, you see.

Photography was always a safe place, it was home for me, and as the years wore by, I became more and more involved with the studio, appearing there ever more often after school and on summer breaks to assist. It was only natural that I began photographing early on, and was proficient at it by the time I was a teenager. There was a serious demand on me right from the start—no loafing around. My father would often say that the studio was a place of business not a playground. I was expected to contribute. I was taught to sweep, develop film (both color and black-and-white), print, load view cameras, everything really. By the time I was thirteen I could run the lab's color "line" as everyone referred to it—the E-3 color processor, with its reliable, yet archaic nitrogen blast system of agitation.

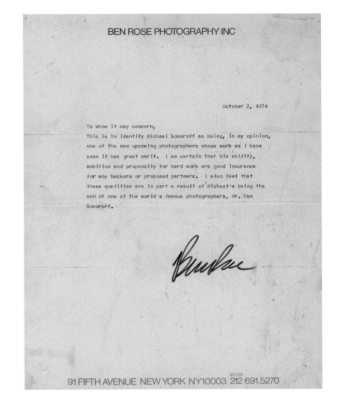

I worked between studios of my father's friends as well, as he would lend me out as cheap labor, and of course, in order to teach me the ropes. I worked regularly with Ben Rose, Louis Faurer, and "Izzy" Possoff. Still life photography became second nature to me and still is. On the job I also had the chance to meet some of the greatest art directors and designers of that age, many of whom were regular fixtures of my father's clientele. Henry Wolf, one of my father's closest friends, was my godfather. Herb Lubalin, Lou Dorfsman, Bradbury Thompson, Robert Benton, and Milton Glaser, to name a few, were all long-term regulars of assignments over the years. It was Milton who actually gave me my first serious job. It was for *New York* magazine where he was art director at the time— a still life of cigarette compacts resulted. [page 86]

My father had become one of the world's preeminent still life photographers by the time I came along. He arrived in New York in the 1940s, together with other friends and acquaintances he had befriended in Philadelphia as a student of the legendary art director Alexey Brodovitch. As photography curator and historian Anne Tucker points out in her monograph of Louis Faurer's work,[8] Lou coined the term "Philadelphia School" in reference to this special group of photographers who had journeyed together from their humble roots to the center of the publishing world in New York City. Except for Irving Penn, who was part of the group, but as a rather renowned recluse mostly kept to himself, the entire clique was close and socialized often. My memories of all of them are fresh even today. Ben Rose, Louis Faurer, Sol Mednick, Arnold Newman, Isadore Possoff, and my

father, in a certain way, can be understood as a specific moment in photography. They shared many of the same assumptions regarding what good image making should be and what it should look like.

My father's key interest being mostly a still life studio photographer, was in his colleague Irving Penn's work. He considered Penn his only true peer. I remember him vividly saying that Penn was honestly "the best." That there was "no touching him," as he put it. He even joked once when business was slow, that he was going to change his first name to his last name and make his first name "Irving," thus becoming "Irving Ben," and benefiting from Penn's "spill-off," as he put it.

He admired Penn's still lifes very much while at the same time taking a deeply respectful yet competitive posture toward his colleague. They both worked for Brodovitch and were powerfully influenced by him. At the time, Brodovitch was the art director of *Harper's Bazaar*. Another photographer, Leslie Gill, a bit older than my father and Penn, was a regular contributor. Both Penn and my father looked up to Gill—my father referring to him as "the real master." My father would talk often about the enormity of Gill's talent and his influence on he and Penn—there was no secret there between the photographers—it was in the family, so to speak. Gill was the precedent. The official record needs to be re-examined.[9]

Many people don't know of Gill's work even today because tragically he died rather young, in 1958. But talk of Gill's work was a constant around the house and my father's studio. There was an invariable faithful presence of Gill and secondarily, Penn, in our lives. My father often compared his own work with theirs, studying what they were doing in competitive reverence. The three photographers' art is linked intimately and it's easy to demonstrate—but I'll leave that for another publication. It's not far-fetched to say that without Gill's influence Penn might never have developed the style he became famous for and my father's own work might have taken a totally different direction. It was all underwritten by Brodovitch. More about that later. Our family archive demonstrates this beyond any shadow of a doubt.

Gill was the consummate classicist; deeply influenced by European painting, he created still lifes and portraits that were robustly classical and composed according to the most time-honored rules. His work was extremely painterly and he borrowed constantly from the medium, which in fact made it a bit unusual in those times as serious photographers were mostly trying to distance themselves from painting in order to legitimize photography as art.

One of his many influences was the Philadelphia still life painter William Harnett. Harnett had a strong presence in the academic art world of Philadelphia and it is certain that Gill and then later, Penn and my father, were familiar with his work. Gill's still lifes attest to this, as many are literally compositional appropriations of Harnett's paintings. There are also many examples, in turn, in Penn's and my father's early work that unquestionably prove the influence of the Harnett-Gill connection even to the point of outright lifting of props,

subject matter, and formal execution. Penn's first published cover for *Vogue* was a conceptual lift of Harnett and Gill, without a doubt.[10]

Gill also shot portraits and very good ones at that. Although, like my father, he was more known for his still life and fashion work. A comparison of his and Penn's portraiture is very telling. The influence is clear and very glaring. My father also did portraits and stylistically they strongly emote the same classicism that Gill's and Penn's do, but my father was never seduced by portraiture the way the other two men were, owing to the fact that my father's first love was composition. Although both Penn and my father were revered for their still life work, it was also their point of divergence. My father's fascination was with the building of subject matter within the frame, the more complex the better, where Penn would develop for most of his life, a propensity toward the austere and graphic. It is telling that both photographers ended their careers doing flagrantly classical still lifes.

It's easy to jump from still life to portraiture as long as the portrait relies heavily on composition and lighting. This jump is a method for transitioning with its roots long established in painting—portrait painters practiced on still lifes. It's worth mentioning that I believe both Gill and Penn's love of still life was certainly the foundation of their portrait work. It all ultimately began with setting and composition. Fundamentally the starting point for all of their portraiture was that they composed the portrait like a still life, seeing their subjects almost as props at the onset as opposed to letting the subject's spiritual life dictate the personality of their imagery. This evolved over the years. Penn certainly became more focused on the specific persona of those sitting for him as he became more confident. On the other hand, my father lost interest almost entirely in portraiture—except for a single massive assignment he did for Steinway & Sons, where he was asked to photograph all the great artists involved with Steinway. This resulted in a portfolio of portraits of many of the greatest musical talents of the twentieth century. I remember these sittings because they were unusual for my father as they were outside the studio routine of still life production. In other words, portraiture was basically a way of being different from my father.

My father's sense of competition with Penn formed a strong base of inspiration for some of his best work and deeply influenced me, of course. In a certain sense my father and Penn represented a single creative persona

to me, an imaginary synthetic photographic personality that profoundly operated within me. On the one hand was Penn's austere, graphic sense of composition; on the other was my father's ability to compose with complexity. Both artists' works shared a mastery of photographic technique and a reverence for classical color, composition, and lighting, which ultimately is what merged them together for me into a single imaginary personality.

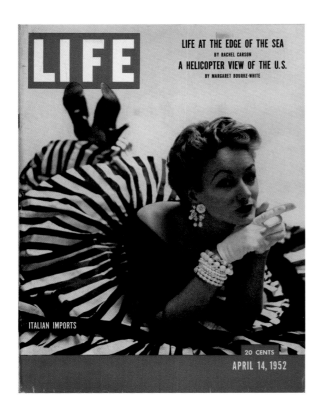

In those early days of my life both of my parents were thoroughly engaged in their careers. My mother, Alice Bruno, as she was known professionally, was one of the original Ford models. Eileen Ford, one of the first to establish what was to become the ideal for the modern modeling agency, visited the hospital the day I was born, I was told. My mother modeled for Horst, Mark Shaw, Francesco Scavullo (with whom my parents shared summer dwellings in the Hamptons), John Rawlings, Diane and Allan Arbus (who were just down Fifty-fourth Street from us), and Frances McLaughlin-Gill (Leslie Gill's wife). Just a few years before I was born my mother graced the cover of *Life* magazine—an ultimate achievement for any fashion model of the day. She met my father on assignment for *Mademoiselle*.

The world of Madison Avenue—its advertising agencies and magazines, in the 1950s and '60s was glamorous and exciting. Together with the movies, the magazines were the cornerstones of our culture's most treasured fantasy of itself. My parent's social milieu included some of the most influential people of the period. Milton Glaser, Robert Benton, Salvador Dalí, Marian Anderson, Art Kane, Truman Capote, Norman Mailer, Bradbury Thompson, André Kertész—the list is too long to recount here—were all in regular contact with my parents. Many of these people became my heroes—some, my mentors.

My parents were very busy and I longed for their attention. One way to get it was to join the ranks, so to speak. A simple reading of this period of my life is that like many sons, I was following in my father's footsteps. Looking back now I see it differently, I longed for attention. A keen sense of competition collided with my love for my father, and my own journey began in earnest. I was becoming a teenager. This is not to be understood as anything particularly dark. Like most sons I suffered from a complex set of emotions when it came to my father. On the one hand I wanted to be like him, on the other hand, I wanted to beat him at his own game—if just to get his or maybe even better, my mother's attention. Make no mistake about it, I loved both my parents deeply and I forgive them their "trespasses" so there should be no confusion here—I was devoted to my father until his last day.

By the time I was twenty-one I had worked with several of the world's greatest photographers and I was doing pretty solid large-format still life work. I was out on my own—I opened my first studio with $3,000[11] and support I had received from a few friends and a business partner several years my senior. Up until that time I hadn't done any studio portraiture. The presence of my parents' social milieu, of course, remained constant, including that of Richard Avedon who had intervened on my behalf and mentored me into my first museum exhibition at the then-fledgling International Center of Photography, in 1979.

• • •

Brodovitch's philosophy was a constant background hum in those days. The demand to look beyond any effort that was derivative for one's own authentic artistic voice was the topic of many dinner table conversations. It created a continuous pressure to make original work and reach beyond the status quo. It is one of the great ironies of my life. On the one hand I was being taught to push the limits, on the other hand, I was forever in the shadows of all these enormous talents—a tough spot for a young man. I was searching for a way beyond my upbringing, and portraits seemed like a way out. Portraiture was a neat segue beyond still life because it was a kind of still life for me at that point—one that used people instead of props. Richard Avedon's emotionally charged, often haunting portraits, which were close to me, and also represented a reach beyond my father's accomplishments became a vision of a way of getting clear of the hard contours of my own indoctrination, which of course was my longing. Avedon's portraiture was real medicine at that moment because it represented everything artistically my father's work was not. Many of the portraits were raw and unstaged— they were opposite to my father's classically formal constructions.

I knew Avedon through my parents and he had very generously taken the time to guide me beyond magazine work, which of course was my syntax, into the possibility of practicing photography as art—which was in the air at the time. It was an idea that was very new to me. He was very charitable, offering me advice on many life subjects and my career, which he was instrumental in launching. His example was a very good illustration of the *photography-as-a-way-of-life* approach mentioned earlier.

I remember how ardent Avedon was about the necessity of "living" the image—having it result from being a part of the incident one was photographing rather than it simply being the result of a kind of voyeurism. Looking back now, it's easy for me to see that at the time, he was struggling with transcending his persona as one of the world's most successful fashion photographers, and really getting up close to the despondence and isolation that so intrigued him and informed his work. During that period Avedon had been getting the cold shoulder from the art world, which minimized him as a "fashion photographer" in response to his first major retrospective show at the Metropolitan Museum of Art.[12] I remember that he was frustrated; I even detected a real hurt just beneath the surface. He was deeply impressed by the photography of Diane Arbus

and others like Louis Faurer and Walker Evans; their work was of course the exact opposite of the elegant, refined fashion work Dick had produced for the magazines and maybe that's one of the things that attracted him to it.

A turning point was our getting together for a review of my work—something I was doing constantly at the time. I would keep after all of my heroes for crits.[13] Much to my surprise, Dick focused his critiques on questions regarding how to live life as opposed to artistic concerns. He had a lot of almost frenetic energy; he was very

sharp, intuitive, and brilliant—and one felt it immediately. You had to pay attention to keep up. He tutored me on everything from sexuality to money management, running through a kind of collision course of life topics I guess he felt were bottom-line issues that should show up somehow in good work, *inevitably*—and of course they did *eventually*. Once again, it was all about the photography.

Avedon equated life with photography, maybe this is one of the reasons he was so prolific in his output and so evocative in the depth of his work. He pushed me hard to question my assumptions, which as a young man in my early twenties were many: where I came from, who I was, and more important, who I wanted to be. He cautioned me

to always use the camera as a means of asking those questions. He gave my aspiring career a serious jumpstart by introducing me to Hiro (Yasuhiro Wakabayashi) and Cornell Capa. How ironic that this volume exists without Avedon's portrait. He probably would not have sat still, but it's my fault as there were certainly opportunities along the way at least to nag him. I should have taken more responsibility and listened more carefully to his advice: Live through the lens. Had I, more so, his picture might have been here. I guess I just always thought we'd get around to it. . . . That is once I got the courage up to ask.

As the years have rolled by, I have grown to cherish the time and the advice Dick gave me. He spent more time with me than I had any right to and I remain exceedingly grateful for his sensitive support. I still often revisit his counsel, most of which, has proven to be correct.

It was impossible for me to think of Penn and Avedon separately in those days. Their mutual connection to *Vogue* during that period with its sweeping influence, cast a long shadow on anyone active in the magazine world. Inspired by all of this, I began to explore doing portraiture as a way beyond the syntax of my

upbringing. The images in this book are, to a great extent, my first attempts. In time, I was to fall deeply in love with portraiture—it is still my favorite exploit, it is still a way out.

• • •

The whole thing of my taking portraits came together as a result of many things. Not the least of which was studying Penn's series, Small Trades, as presented in his fantastic book *Moments Preserved*—a volume I grew up with, and then seeing the publication *Worlds in a Small Room*, in 1974, while in high school. I was just graduating and I decided to use it as a model, a kind of learning tool, if you will, to see if I could create reasonable imitations. I'll never forget the first portrait I did. After some time studying Penn's book, I set up a light on a stand in my first studio on the second floor at Thirty-first Street and Park Avenue. A broad soft tungsten light diffused with tracing paper was my initial experiment. I don't think the light very remotely resembled Penn's. Actually it didn't look like it at all. I had done some research and discovered that Penn's portraits had mostly been done with a middle format Rolleiflex, so I had borrowed my father's Hasselblad, which would eventually become my own. It's the camera I still use for much of my portraiture.

But the bigger problem was, of course, that I had no subjects to practice on. Below my studio was a Chock Full o' Nuts coffee shop, then a popular chain around New York. I would go there several times a day to buy coffee. One day I noticed two waitresses who looked to me like they had stepped right out of one of Penn's "small rooms." It occurred to me that I could buy people cups of coffee in return for them coming "just" upstairs to the studio and modeling for half an hour—a portrait for a cup of coffee; a cheap swap. These people were my "small trades," found over a cup of coffee. That's how it all started, very naïve, very innocent, very passionate. I started with portraits of two waitresses.

I believe very strongly in the apprentice system. I am convinced that there's nothing new under the sun. We do the same old thing; tell the same old stories in our own unique way and time. Of course, I had no choice but to adopt this point of view, I understand that. So many exceptionally talented people surrounded me. Appreciating that I was standing on their shoulders was obligatory to my spiritual survival. Eventually this would become a great advantage. It informed me with a kind of meekness that attracted the encouragement of many of these masters as my mentors. I knew my place—regardless of how polished my efforts became, I was always in *their* shadow, building on their accomplishments—still am—creating in a sense, on the same old thing yet anew.

So I had to learn what that "same old thing" was. My method, if you can call it that, was to try to start where my heroes had left off. Attempt as an exercise, to stand on their shoulders by imitating them as best I could and using their work as if it were a sketch for me to build on. What I was after was work that would stand the test of time like theirs had. It was clear and it was what I had learned as well from my father, that by mastering

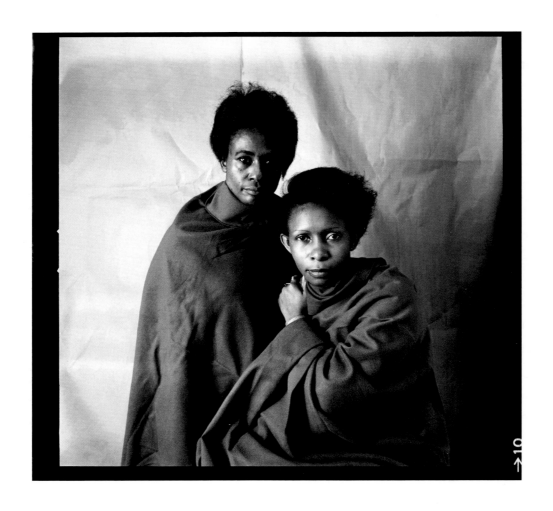

*CHOCK FULL O' NUTS WAITRESSES*, PHOTOGRAPH BY MICHAEL SOMOROFF, NYC, 1978 • • •

the methods of one's predecessors, one is at least guaranteed a certain minimum entrance into a qualitative conversation, artistically speaking. This is probably why I am attracted to the classical as my predecessors were. I know it's good if it has stood the test of time. For me, this is the very essence of quality—how long do we care about it and relate to it. . . . That's classical for me, and I understood that very early on. That's why I can tell you right off, I was always a classicist.

I photographed scores of sheets and rolls of film. I spent most of the nights processing both color and black-and-white. I would print for other photographers as well—Louis Faurer would come by now and then in what was now *my studio* and we would print together. My father was shooting television commercials full-time by then and his stage was a few blocks away. My father and I would lunch regularly together. I had no money, so he would pay, ordering us cannelloni at this restaurant across from his office on Thirty-second Street— Howard Zieff's[14] former studio. Sometimes I would assist him on a stray print job, some residual from an old friend. He often came by to advise me on life and photography. It was a wonderful time for us and we were very close in those years, just before I really took off on my own and left for Europe. He would occasionally help me shoot a job, tutoring me on the solution of a particularly challenging problem. He liked what I was doing with people in my pictures; particularly my nudes and these portraits, which I guess is why he sat for me not once, but twice.

I learned a lot very quickly because I was obsessively driven and deeply passionate. One has to appreciate how fanatical I was in order to understand the pictures here. I breathed, ate, and slept photography. I was always on the hunt.

I wouldn't go home or leave the studio. Girlfriends had to visit there. Social events all happened there. I would often sleep there so I could keep working. For that matter, on many occasions, I wouldn't even sleep. I would take a nap, eat a chocolate bar or push by the prostitutes on my way to the Belmore cafeteria on Twenty-eighth Street and Park Avenue South, the same one featured in Martin Scorsese's *Taxi Driver*,[15] have a stale glob of tuna-noodle casserole topped with crushed potato chips, get sick, and then go back to shooting and printing. I had built a darkroom in a small crevice facing Thirty-first Street that had been constructed to house an industrial air conditioner. I needed a darkroom because I was so impatient that I couldn't wait to see the negatives of my portrait shootings. This way, I could shoot, and ask my subjects to wait, while I gave them another cup of coffee and processed the film. I'd go into the darkroom and develop really fast (often destroying half the sitting!) and make a wet contact sheet, as I had learned from Izzy Possoff (keep in mind, there was no Polaroid when he was working), by placing the negatives between two pieces of Saran wrap to keep the photographic paper dry.

Following that, I added a kitchen in the studio. As I was always there and had so little money, it was helpful to have a place to cook instead of going to the Belmore endlessly, which was time-consuming and ate up

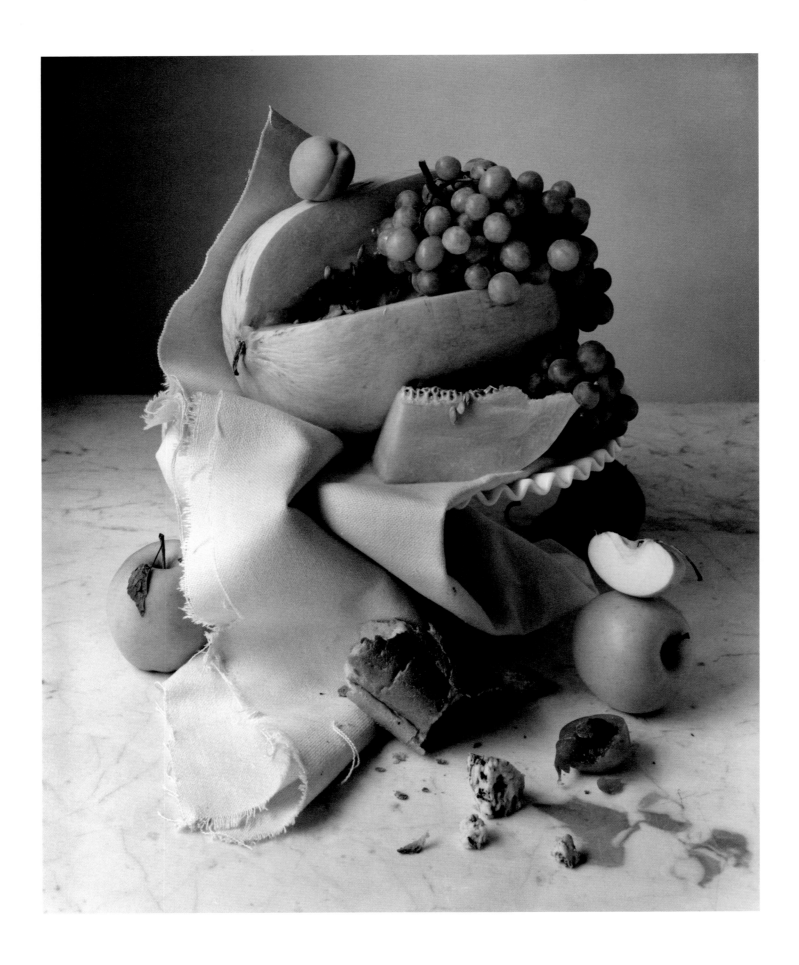

whatever little money I had. I was just barely managing on a weekly salary of about $75. After the kitchen, came a proper studio, with photographically organized window light, no less. Now I could shoot daylight portraits and make natural light still lifes of food and other things. It all grew organically out of this project of teaching myself, through trial and error, study and good advice, how to do a portrait. My whole professional life really took shape according to those early portraits.

I had been doing these Chock Full o' Nuts portraits for about six months, and I was talking to somebody about portraiture and studying everyone's work, when one day I asked a friend if he knew how Penn had achieved a certain quality in so many of his earlier still lifes. He mentioned to me then that many of Penn's portraits and early still lifes were done with daylight. Of course, I had been using the "wrong" light.

I had been shooting with studio lights and was frustrated by my inability to master a great portrait look. There was a wonderful, huge window in the studio. I immediately set out to master natural light, or better, daylight. Mine turned out to be south light as opposed to the popular north light.[16] There was a beautiful film in those days. I miss it terribly. It was called Super-XX. Kodak made it. Like so much original photography stuff made of materials like platinum, silver, and so on, it is not made anymore. Many photographers, of course, used it, and it had a very specific rendering of gray scale. It had a much more one-to-one gray value than today's panchromatic films. It matched well with daylight. The first thing I did, once the space was transformed into a full photography studio, was set up a still life using that window as my light source on Super-XX. I learned how to use daylight in a still life before I ventured out into exploring its use in portraiture as I was much more confident of my ability to do a decent still life.

I practiced endlessly in front of that window. Even today, when I occasionally pass by that block I affection-ately glance up—I spent so much time there and learned so much. It remains a sacred place for me. I fell in love with portraiture in front of that window and had my first experience creating real communion with my subjects there. Some of the portraits in this book happened in front of that window. After what seemed at the time to be an eternity of practicing, one day I thought, okay, let's stick a person in front of the window and try to figure out how to really do a serious picture.

The chance came not long after, with a job for a brand of vodka I was working on, when the account executive came to the studio with the bottle to shoot. He looked like a cartoon to me. It was incredible. I thought, "I have to shoot him in front of the window," and I still have that picture. It was really my first solid portrait, meaning that it looked a lot like my heroes' portraits. I was very pleased. I had figured out how to do it.

It is a method I deeply believe in—*imitation*. That was not something to apologize for, and I'm still not apolo-getic. What matters ultimately is the emotional impact of the image, not its formal language. Besides, it has a long tradition—so I take criticism of this with a grain of salt. That is not to say that one needn't find their own

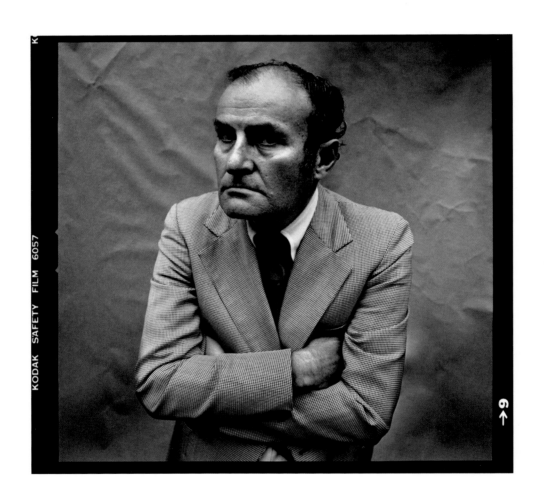

ADMAN, PHOTOGRAPH BY MICHAEL SOMOROFF, NYC, 1978    • • •

voice in the work—that is the goal. I even have a test I use to see how I'm doing. I pile up my work with that of others, all of it unlabeled, and ask someone unfamiliar with it to see if they can separate out my work from the rest. If they can identify mine from the mix, if a strong style that is related to the emotional content emerges, then I'm on the right track. In the end, I find that you can't really plagiarize if you're honestly searching for a truthful experience of the moment you take the picture, because through the practice of searching for it and its repetition, you eventually lose your ideas about what you're doing and end up with intuition as a replacement. That's when the work becomes capable of real communion. The result is that you end up doing it from the heart, your way. It's that instant of emotional connection I am always searching for. I don't really care about the rest. Experience has taught me that it's the only thing that lasts: that intimate moment of contact between the viewers, the photographer, and the subject.

The image lives according to how poignant that psychological crash is. For me it's the whole point. I am much less concerned with formal considerations, technique, circumstance, "who it is," "who was it done for," etc., than I am with receiving an emotional punch in the stomach. In my experience, those seemingly endless conversations rooted in other considerations around the work, are most often furthered by those not capable of creating that power through the art themselves.

That portrait of the vodka adman, I remember clearly, was the turning point. I got very excited, feeling as though I had some craft to support my interest in portraiture. I was only twenty-two-years-old, full of myself, and full of enormous enthusiasm. It was all something between play and real. I mean the whole thing was a game for me in some way because I had nothing to lose. I just phoned these masters up and suggested in most cases that they *come to my studio* and be photographed—pretty ballsy. It's astounding to me now that I had that kind of confidence or better, arrogance even. I don't think it ever even occurred to me that they might say no and by the way, no one did. *That's telling*.

The only photographer it didn't work out with was Berenice Abbott, who I spoke to regularly over the phone. She was quite elderly and in Maine most of the time then. Our schedules kept rear-ending into each other—of course I regret that I wasn't more engaged in making sure I got her portrait. It's that "live through the lens" thing again. . . .

There is no doubt in my mind that the reason for everyone being so agreeable was that I explained how much I admired their work (flattery will get you everywhere), which was true, and how much I desired to *learn* from them (also true). To know these giants of photography was a great privilege and I understood that. To be their student was even more so. They felt that I knew that, which was a very important element of all this.

As I have described, times were very different then. The world was slower and people generally had more interaction. You could get someone on the phone, have lunch with an art director—projects came at least

weeks in advance, many came months in advance, which meant that there was time to plan, reflect carefully, discuss, and even more important, there was time to experiment. This, of course, was the only way to find something truly "new," not only something we tell ourselves is new, meaning mostly "novel"; rarely is the work I see today truly innovative. Of course thankfully there are some exceptions. . . .

Because there was contact between people in a more personal way then, there was no alternative—you had to get together just to get the information. As a result, there was more collaboration and a much greater sense of camaraderie. It was understood that each generation had a responsibility to support the generation following. Although this still seems to be the case today, it has become to a great extent a superficial promise; a hollow assurance that pays lip service to the concept that experience matters. The big difference today is that often the privilege of having access to the former generation's experience, i.e., their wisdom, is no longer considered a key ingredient to success. Wisdom is confused with information and the goal of education now is primarily to enable one to get a job. For the most part, the concept of success has become more about income and status rather than about self-realization. But Brodovitch was about self-realization, as was my father, Penn, Avedon, Arbus, Faurer, Newman, Brassaï—the whole bunch. Make no mistake about it, for them picture taking was a way to self-realization. That was the commitment you made that made it all possible. Louis Faurer could sacrifice a meal, not a good picture.

I know, I was there.

The photographers I reached out to felt my passionate plea to know them and make them my *life* teachers. It wasn't hidden or subtle, rather it was my badge of courage. It was the whole point. In turn, they felt a responsibility to give to me, as a representative of the next generation, and invest in their own immortality by sharing the benefits of their experience. In a sense we were all colleagues—we were all part of one society of image makers (I was thrilled when Brassaï substantiated this by referring to me as his colleague—pictured here in the book he autographed for me [page 68]). I was part of a long chain of a fluid inheritance of craft, life experience, and passion that kept the conversation fresh concerning the production of our photography. As much as these great photographers, many my teachers, were my heroes, I was their continuity. As the pictures here attest, we were *collaborating*—often experimenting together, which is why the photographs include so much risk.

The first portrait of this series that I executed in front of that large studio window was of Frances McLaughlin-Gill. I knew Frannie's work very well through my study of her husband Leslie Gill's work, and had seen it in my mother's modeling portfolio as well as in books we had around the house. It seemed like a good place to start with doing serious portraits, i.e., portraits of famous people, given my history and my admiration for Leslie Gill as the preliminary stepping-off point for my father's work. It felt like home.

This body of work has found its way into this publication almost miraculously, through the care of others. For that I am truly surprised and grateful. I am deeply touched that anyone would find any of this interesting after so long. These photographs were taken when I was a very young man, full of desire and the yearning to make something of myself. I was driven by raw enthusiasm without much finesse. Yet people were very generous and opened themselves to me. I made friendships that have lasted a lifetime and that I continue to grow from. I had the chance to know a time through many of the masters of photography that is now gone forever. Unbeknownst to me then, it was to be the apex of classical photography, a "moment." I am profoundly grateful to have had this chance. It has enriched my life and still does in ways that are surprising and substantial. Most of all, I carry each and every one of these sittings in my heart every day. They are with me and I return to them regularly for counsel. I remember each sitting as if it was only yesterday. Each was a life event, an adventure, important for me, leading to a refinement of my own art.

I can only hope that my pictures, our collaborations, have given each and everyone of these great people, these giants of photography, the due I certainly owe them and a chance for all of you to get to know them a little bit, too.

MICHAEL SOMOROFF  NEW YORK CITY, 2012

SOMOROFF.
PORTRAITS
GROSSER
FOTOGRAFEN.

PPS.
GALERIE
F.C. GUNDLACH
FELDSTR HOCHHAUS
2000 HAMBURG 4
TEL 040/43 06 84
17XX41 O64

Notes

1.  This whole project began, as I said, innocently, when I went to my printer with the image of Frances McLaughlin-Gill. I was testing how the image might look in platinum and had chosen it because it is so classical. After seeing the final print I thought to myself, "this looks great, let's do the whole series this way." Some weeks later I returned to the darkroom with about twenty negatives from the series, which I proceeded to scatter on the desktop. My printer took me by surprise by literally gasping, "Wow! These are the Greats—and you know, most of them are dead!" At first I didn't really understand. I responded "So? Who cares if they're dead or alive? I just think it's a nice series and they'd look good in platinum. Don't you think?" But my printer insisted that the series was important because the group of portraits represent the last moment in photography before the switch from analogue to digital. I thought that was an interesting take, so I showed it to several other people whose judgment I respect. The result is this book. I am very grateful to my printer and all the others for their enthusiasm and insight. Otherwise, I never would have spent the time revisiting these images in any serious way.

2.  In those days films were much less sensitive or "slower." One measured their sensitivity or "speed" by what was called the ASA (American Standards Association). Studio photographers like my father used Kodachrome film early on, a beautiful and rather permanent (the only one) color film that could only be developed by Kodak in Rochester, New York. The original speed of Kodachrome was eight—a far cry from today's films, with sensitivity climbing into the four digits.

3.  My mother was known professionally as Alice Bruno. Born in Tacoma, Washington, she traveled to Hollywood where she briefly became an "MGM girl." She was recruited to New York via her fur modeling in Arizona and was represented by Eileen Ford of the legendary Ford Agency. Her many accomplishments and accolades include gracing the cover of *Life* magazine on April 14, 1952, and in 1956, being listed with Ann Klein, Mary Jane Russell, Georgia Hamilton, and others, as one of the most famous fashion models of the day.

4.  Leading magazine photographers were expected to deliver "perfect" visual solutions to any editorial and advertising assignment and were expected to possess the craft to solve all kinds of visual challenges. My father routinely used multiple exposures, in-camera matting, and an endless array of darkroom trickery to problem solve. This often required an extra set of hands, thus giving me an opportunity to learn and help.

5.  There was often talk of the importance of a photographer getting in close to what was going on as a requirement to capturing a great photograph. I remember distinctly Louis Faurer sitting me down and lecturing me on this topic. Louis did not believe in long lenses because, as he put it, "they turn you into a voyeur." He thought that a lens between 28mm and 35mm on a 35mm camera was the "correct" lens, i.e., the "normal" lens for the format. Beyond optics, what these focal lengths required of course was getting in close to the center of an event. Inevitably, so close that you become part of it. Louis wasn't the only one who felt that way. He often cited Diane Arbus, Henri Cartier-Bresson, and Walker Evans as photographers who were not "hiding behind the lens," but took risks as it pertained to being intimately close to the action and in one's face, so to speak.

6.  For most of my early life, photography was not considered an art form. Rather, it was artistic—meaning, that because it was so dependent on reality unfolding before the lens, it was considered more a documentation than a free creative expression.

7.  John Rawlings's luscious and elegant images graced the pages of *Vogue* regularly in the 1950s and 1960s and can be seen in *John Rawlings: 30 Years in Vogue* (Arena, 2001).

8.  When Louis Faurer passed away in 2001 Anne Wilkes Tucker organized his retrospective exhibition for the Museum of Fine Arts in Houston, which then traveled throughout the country for several years. Tucker also authored the monograph *Louis Faurer*, which illuminated his substantial contribution to street and documentary photography. In the book, Tucker is the first to reference Faurer, my father Ben Somoroff, Irving Penn, Arnold Newman, Ben Rose, Isadore Possoff, and Sol Mednick as forming the Philadelphia School of photographers. They were all close to Alexey Brodovitch and their influence on the photography of that time cannot be overstated. (*Louis Faurer*, by Anne Wilkes Tucker, with Lisa Hostetler and Kathleen V. Jameson. London: Merrell, in association with Museum of Fine Arts, Houston, 2002.)

9.  Leslie Gill had been working for the magazines since 1935 and was well established by the time Penn and my father began doing editorial assignments in the early 1940s. His contribution to the American still life photography aesthetic has been all but ignored and needs to be explored.

10. *Vogue*, October 1943.

11. Even with inflation taken into consideration, $3,000 was really not enough to "open" a studio. I moonlighted as an assistant and worked as a carpenter, short-order cook, and movie light repairman, not to mention a whole slew of other part-time positions, to fill the gap. I ate pasta for breakfast, lunch, and dinner.

12. *Richard Avedon 1947–1977*, a retrospective exhibition was shown at the Metropolitan Museum of Art, New York, September 13 to November 5, 1978. *Avedon: Photographs, 1947–1977* was published concurrently by Farrar, Straus & Giroux.

13. I had prepared a long list of people I admired, which included a whole gamut of people in the arts.

14. Howard Zieff, a highly successful advertising photographer in the 1950s and 1960s, was one of the first to transition from still photography to filmmaking. He directed many well-known films such as *Slither, Hearts of the West*, and *Private Benjamin*. He set the stage for great developments in the visual language and artistic integrity of commercial production and bridged it to other media, something that today is taken for granted.

15. Scorsese's *Taxi Driver* was released in 1976, the year after I graduated from high school, and was all the rage. It was exciting to go the Belmore cafeteria for meals late at night and sit with the taxi drivers and passing prostitutes, as it felt like being *in* the film. It was a powerful experience for me that helped to establish the authority an image on film could have in creating a psychological environment.

16. As in all fields, the practitioners of photography have their own pet myths. One of them is "north-light," natural light coming from a window facing north. It is supposed to have a magical quality I have until now still been unable to detect. I do not prescribe to lighting formulas. Technology means very little to me—don't get me wrong, masterful craft is crucial to the artistic process because it frees one to make creative choices. Fundamentally, though, it is a means to an end.

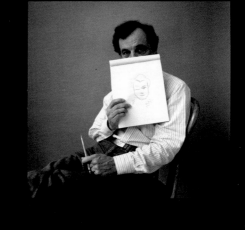

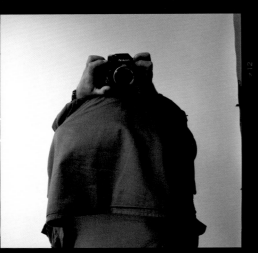

KODAK SAFETY FILM
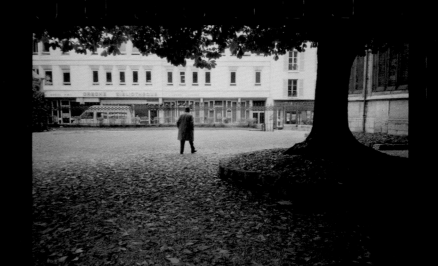

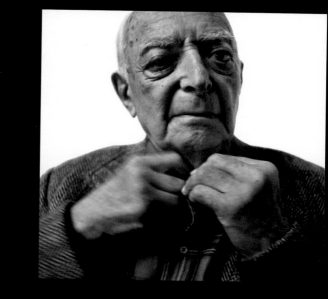

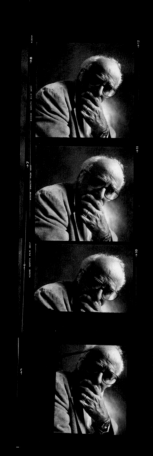

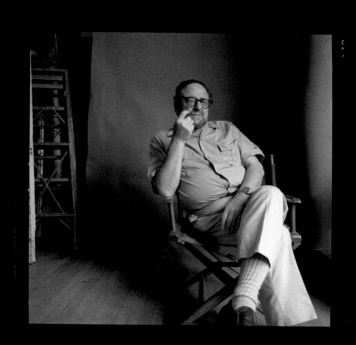

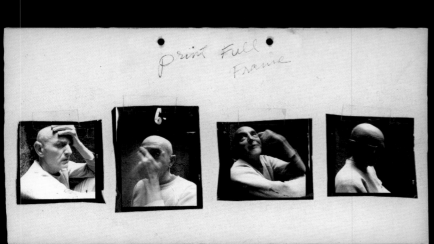

Print Full Frame

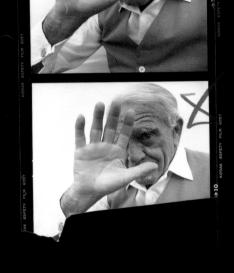

KODAK SAFETY FILM 6057

→ 11

KODAK SAFETY FILM 6057

→ 10

KODAK SAFET

→ 12

→ 11

→ 10

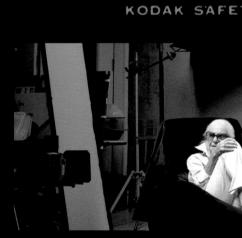

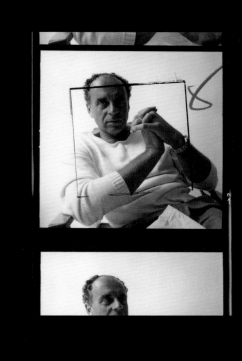

PAGES 104 AND 105, CLOCKWISE FROM TOP MIDDLE:
BERT STERN WITH SELF-PORTRAIT DURING SITTING,
1979; BRASSAÏ BUTTONING SHIRT BEFORE SITTING,
1983; BEN SOMOROFF CONTACT STRIP, 1979; ARNOLD
NEWMAN, 1979; SOMOROFF'S SEQUENCE STUDY OF
DUANE MICHALS, 1980; ANDRÉ KERTÉSZ LEAVING
PORTRAIT LOCATION, PARIS, 1982; ART KANE FOOLING
AROUND, 1979; KERTÉSZ ON HOTEL BALCONY;
GLASSINE ENVELOPE OF SOMOROFF'S KERTÉSZ
SELECTS; CONTACT SHEET OF SID KAPLAN, 1979.

PAGES 106 AND 107, CLOCKWISE FROM TOP MIDDLE:
HORST'S STUDY, OYSTER BAY, LONG ISLAND, 1980;
RALPH GIBSON CONTACT SHEET, 1980; DUANE
MICHALS CONTACT STRIP; FRITZ KEMPE'S HAND,
1983; CORNELL CAPA AND HIS DOG DURING POR-
TRAIT SITTING; LARTIGUE DURING SITTING; ROBERT
DOISNEAU PHOTOGRAPHING, PARIS, 1983; LARTIGUE
CONTACT SHEET OF SITTING, 1983; F.C. GUNDLACH'S
HANDS, 2011;  HERMAN LANDSHOFF CONTACT SHEET
OF SITTING, 1979;  SID KAPLAN CONTACT STRIP,
1979; HORST CONTACT STRIP, 1980. MIDDLE IMAGE:
LILLIAN BASSMAN DURING SITTING, 2011.

### Lillian Bassman

American, born Brooklyn, 1917; died New York, 2012

Lillian Bassman studied at the Textile High School with the legendary Alexey Brodovitch, and graduated in 1933. In 1941, she began working at *Harper's Bazaar* under Brodovitch, where she learned the trade of magazine art director, later becoming his first salaried assistant. In 1944 she was appointed art director of *Junior Bazaar*. In addition to providing innovative designs, Bassman gave prominent display to future stars like Richard Avedon, Robert Frank, and Louis Faurer, whose work whetted her appetite to become a photographer herself. In 1946 she decided to learn photography and spent hours at *Harper's Bazaar* mastering printing in George Hoyningen-Huene's darkroom. After only two months as a photographer, Bassman acquired a major account and a regular job as a photographer with *Harper's Bazaar*. In 1949, she photographed her first Paris collection for *Bazaar*. From the 1940s until the 1960s she worked as a fashion photographer. In 1971 upon closing her studio she threw out all of her negatives in garbage bags. Twenty years later, her downstairs neighbor, the painter Helen Frankenthaler, discovered the discarded bags in the basement. Bassman printed from those negatives until the end of her life.

### Brassaï

French, born Gyula Halász in Brasso, Transylvania, 1899; died Paris, 1984

American writer Henry Miller christened Brassaï "the eye of Paris," and his images of street and night life, populated with underworld and underground characters, do indeed epitomize that darkly romantic capital of the 1930s. After studying painting in Budapest and Berlin, in 1924, Brassaï moved to Paris and supported himself as a journalist. With encouragement and a camera borrowed from his friend André Kertész, he took up photography after finding painting lacking in immediacy. Brassaï captured the misty streets and smoke-filled cafes with the immediacy only the camera could convey. The sense of a time and place is strong in Brassaï's Paris photographs and over the years, they have come to virtually define the ambience of the society he documented. Brassaï associated with the Surrealists and his book *Paris de Nuit* (1933) is a classic example of personal, interpretative documentation. Later, Brassaï expanded his vision to include wall graffiti and portraits of artists and writers such as Picasso, Henry Miller, Jean Genet, and Alberto Giacometti.

### Cornell Capa

Hungarian-American, born Cornell Friedman in Budapest, Hungary, 1918; died New York, 2008

Cornell Capa initially intended to study medicine. Instead, in 1936, he joined his brother Robert in Paris to pursue photography. He moved to New York City in 1937 to join Pix Photo Agency. He worked for *Life* magazine, and became a member of Magnum Photos in 1954. Capa was a noted photojournalist, and his career as a photography impresario began in 1962, when he started the International Fund for Concerned Photography. The success of many projects spurred Capa to create a permanent site for the exhibition and ensure the preservation of humanistically oriented photography. He purchased a rundown mansion on Fifth Avenue and Ninety-fourth Street in New York City, and on November 16, 1974, opened the International Center of Photography with an exhibition of the work of Henri Cartier-Bresson. The program at the new institution was remarkably multifaceted, combining exhibitions with public lectures, symposia, weekend workshops, publications, and maintenance of an archive of original prints. Sixty-one shows were presented in the museum's first three years, ranging from retrospectives of the careers of his brother Robert Capa and W. Eugene Smith, to group exhibitions such as *The Julien Levy Collection: Starting with Atget*. In 1979 Capa gave Michael Somoroff his first exhibition.

### Robert Doisneau

French, born Gentilly, Val de Marne, France, 1912; died Paris, 1994

Robert Doisneau is one of France's most noted photographers, known for his playful, whimsical, and iconic images chronicling everyday French life. In the 1930s he used a 35mm Leica and roamed the streets of Paris, mingling social classes and eccentrics in contemporary streets and cafés. He took thousands of photographs, striving to capture the pulse of Parisian life. He is credited, along with

Henri Cartier-Bresson, for being one of the innovators of photojournalism. His photographs convey what he called "the marvels of daily life." His most famous image is the couple kissing in front of the Palace of City Hall, Paris, taken in 1950. He was appointed a chevalier of the French National Order of the Legion of Honor in 1964.

### Alfred Eisenstaedt

German-American, born Dirschau, West Prussia, 1898; died New York, 1995

Alfred Eisenstaedt is known as a preeminent master of the candid photograph and a pioneer in the field of photojournalism. He perfected certain techniques for capturing the spontaneous moment that have given us some of our most enduring images. Eisenstaedt was fascinated by photography from his youth and began taking pictures at the age of fourteen when he was given his first camera, an Eastman Kodak folding camera with roll film. He began taking photographs as a freelancer and in 1927 he sold his first photograph and began his freelance career for Pacific and Atlantic Photos' Berlin office in 1928 (which was taken over by Associated Press in 1931). By 1929 he was a full-time photographer, and by 1935 Eisenstaedt had acquired a Rolleiflex camera and immigrated to America. A year later he became one of the four original staff photographers for *Life* magazine, working there from 1936 to 1972. His photographs appeared on eighty-six *Life* covers.

### Elliott Erwitt

American, born Paris, 1928; lives in New York

Elliott Erwitt, known for his majestically humorous photographs, was born in Paris and spent his childhood in Milan. His family moved back to Paris in 1938 and eventually immigrated to the United States in 1939. Erwitt studied at Los Angeles Community College and worked in a photography lab during World War II. In 1948 he moved to New York City and in 1953 began working for Magnum Photos. Erwitt has created a body of personal work within the framework of a demanding professional practice. Since the early 1950s he has been a highly successful freelance photographer for magazines, advertising agencies, and corporations. For him there is a clear distinction between self-expression

and work for hire—a basic difference in attitude and motivation. His professional work has been in color, while his personal work is strictly black-and-white.

### Andreas Feininger

German-American, born Paris, 1906; died New York, 1999

Andreas Feininger studied cabinetmaking and architecture at the Bauhaus in Weimar, Germany, where his father Lyonel Feininger, an American painter, was one of the founding instructors. After graduating in 1925, Feininger studied architecture at the Bauschule in Zerbst, Germany, and in 1928, worked as a cabinetmaker and as an architect. Meanwhile, in 1927, he had taken up photography. His earliest photographs were exhibited in 1929 in the prestigious exhibition, *Film und Foto*. This particular exhibition embodied the tenets of Die Neue Sachlickeit (The New Objectivity). In 1933, he moved to Sweden, where he established a firm specializing in architectural and industrial photography. In 1934, he developed the extreme telephoto technique that became his trademark. With World War II approaching, in 1939, Feininger immigrated with his family to New York City and began freelancing. In 1943 he became a staff photographer for *Life* magazine, a position he held until 1962.

### Ralph Gibson

American, born Los Angeles, 1939; lives in New York

Ralph Gibson is a master of dramatic understatement. Influenced by the legacy of Surrealism and the writings of Jorge Luis Borges, Gibson's high-contrast pictures, usually focus on one geometric element or a single human gesture, forming a kind of dream-narrative when seen together. He studied photography while serving in the U.S. Navy and subsequently the San Francisco Art Institute. He began his professional career as an assistant to Dorothea Lange, and went on to work with Robert Frank on two films. Gibson has maintained a lifelong fascination with books and bookmaking. In 1969 he established Lustrum Press, which in the 1970s, became one of the leading small publishers. There, he published his own work in books like the *Somnambulist* (1970) as well as many other photographers' work, including the influential and controversial book *Tulsa* by Larry Clark. His photographs are included in over 150

collections around the world, and have appeared in hundreds of exhibitions. He is a commander of France's Order of Arts and Letters. In 2007 he received the Lucie Award for Fine Art Photography.

## Frances McLaughlin-Gill
American, born Brooklyn, 1919; lives in New York

Frances McLaughlin-Gill was a staff photographer for Condé Nast Publications from 1944 through 1955. She was the first woman photographer under contract to *Vogue*. She went on to produce television commercials between 1964 through 1973. One of her enduring qualities was the ability to develop empathy for models in their work and foster real friendships. In a male-dominated industry, this set her apart. She made models out to be real people and her work reflected this. She was married to the still-life photographer Leslie Gill.

## F.C. Gundlach
German, born Franz Christian in Heinebach, Hessen, Germany, 1926; lives in Hamburg, Germany

The work of F.C. Gundlach defines the look of postwar fashion photography in Germany and for more than four decades he shaped the perception of fashion photography in Germany. Working in the 1950s and '60s, using strong contrast effects, he was able to create a style that unified model, clothing, and background into a single composite. His focus was on series and narrative. He has always been open to technical innovations in photography whether it was with 35mm, flash, or color. During the four decades following the end of the Second World War, Gundlach worked for high-circulation magazines in Germany such as *Film und Frau*, *Constanze*, *Annabelle*, *Stern*, and *Quick*. From 1963 he signed an exclusive contract with the magazine *Brigitte*, working for them until 1986, producing more than 5,500 fashion pages as well as 180 covers. F.C. Gundlach was founder of one of the first photography galleries in Germany. He originated the Triennale der Photographie, in Hamburg, and is the founder and director of the foundation Haus der Photographie, which he has endowed with a collection of seven thousand items.

## Ernst Haas
Austrian-American, born Vienna, 1921; died New York, 1986

Ernst Haas attended medical school in Austria, and began his career path as a painter, but abandoned both for photography. In 1947, he became a staff photographer for *Heute* magazine. Just a year earlier, he had acquired his first camera on the Viennese black market, trading the ten kilograms of margarine he had been given for his twenty-fifth birthday for a 35mm Rolleiflex. His first published photo-story, "Homecoming Prisoners of War," in *Heute*, marked a turning point in his career. This same photo-essay was picked up by *Life* magazine. He was then asked to join Magnum Photos, an invitation he accepted. Haas and Werner Bischof were the first photographers invited to join Magnum by the founders, Robert Capa, David "Chim" Seymour, Henri Cartier-Bresson, and George Rodger. He immigrated to New York in 1950 and was seduced by the challenge to start experimenting with color film. He ended up playing a pivotal role in the development of color photography, and in 1953, *Life* magazine devoted an unprecedented twenty-four pages to his first published color essay, "Shots of a Magic City," taken in New York.

## Horst P. Horst
German-American, born Horst Paul Albert Bohrmann in Weissenfels-an-der-Saale, Germany, 1906; died Palm Beach, 1999

Horst studied at Hamburg's Kunstgewerbeschule, a well-known school of applied arts, under the direction of Walter Gropius. While there he wrote to Le Corbusier and was invited to study at the artist's atelier in Paris. In Paris in the 1920s, Horst met the fashion photographer George Hoyningen-Huene and became his photographic model and lifelong friend. In 1931, at age twenty-five, Horst published his first photograph, an assignment for French *Vogue*. He took over as chief photographer in *Vogue*'s Paris studio, in 1934, when Hoyningen-Huene went to *Harper's Bazaar*. This subsequently led to his regular contribution to British *Vogue*. The photographer chose to be known as Horst P. Horst or just Horst. His name became legendary as a one-word photographic byline for different editions of *Vogue* and *House and Gardens* throughout the world. His

photographs came to be seen as synonymous with the creation of images of elegance, style, and glamour. For over sixty years, 1931 to 1991, he photographed fashion, portraits, lifestyle, interiors, and architecture.

### Art Kane

American, born Arthur Kanofsky in New York, 1925; died New York, 1995

Art Kane intended to become an illustrator and attended Cooper Union School of Art and Architecture in New York before joining the army. (He served in the same camouflage battalion as the designer Bill Blass and the hard-edge painter Ellsworth Kelly.) After the war he returned to Cooper Union, and graduated in 1950. While there, he attended a required photography class, which led to a position as a layout designer at *Esquire* magazine and to a job as an art director at *Seventeen* magazine, where he remained for six years. He also worked for a fashion advertising house before deciding, in 1958, to devote himself entirely to photography. Alexander Liberman, then art director of *Vogue*, first asked Kane to do fashion shots, and these, taken with a 21mm camera (which stretches the picture toward the edges of the frame) became his trademark. His style reflected popular culture. He also worked for *Esquire*, *Life*, *Look*, and *McCall's*.

### Sid Kaplan

American, born New York, 1938; lives in New York

At the age of ten, Sid Kaplan saw a black-and-white print develop in a darkroom. The experience hypnotized him and he began his lifelong career of photographing and printing. He has been and continues to be enthralled with what he calls "the magic" of making a black-and-white print. In 1952, Kaplan began his only formal education in photography at the School of Industrial Arts, a New York City vocational high school. At the same time, he attended meetings at the Village Camera Club, which served as a refuge for members of the recently defunct Photo League. After six years he gained enough skill to be hired by Compo, a well-known custom lab in New York. There he printed exhibition and book prints for several Magnum photographers: Philippe Halsman, Robert and Cornell Capa, and

Weegee. At Compo, Kaplan met Ralph Gibson who later introduced him to Robert Frank. Kaplan began printing for Frank that day and still continues that relationship. He has become legendary as a darkroom master who has printed for Robert Frank among others. For years, his commercial darkroom, located on the fifth floor of a building at East Twenty-third Street, on Madison Square Park, was a well-known hangout for photographers.

### Fritz Kempe

German, born Greifswald, Germany, 1909; died Hamburg, Germany, 1988

In the 1950s and 1960s Fritz Kempe was largely known as a teacher in the development of photographs as part of artistic expression. He was among the leading European figures who supervised the creation of archives in their countries and brought out the increased concern for the preservation of rich historical images by instigating historical scholarship and preservation. Kempe was director of the Staatliche Landesbildstelle in Hamburg. In 1964 he received the Culture Prize from the German Society of Photography and the Senator Biermann-Ratjen Medal for his artistic contributions to the city of Hamburg.

### André Kertész

American, born Budapest, Hungary, 1894; died New York, 1985

André Kertész was schooled at the Academy of Commerce in Budapest and began a career at the Budapest Stock Exchange in 1912. He started photographing while a young man in Austro-Hungary, seeking to make a visual diary of his life. In 1925 he decided to devote himself to photography and left his business in Budapest to settle in Paris. There he worked as a freelance photographer for such publications as the *Frankfurter Illustrierte*, *Berliner Illustrierte*, *Vu*, and *Art et Médecine*. He pioneered the use of the small-format camera in photojournalism, influencing photographers such as Brassaï. He was one of the first to photograph Paris at night. During this time he also began his personal photographic studies of daily experience. Kertész was widely known by the time he came to New York City in 1937, where he began a one-year contract

with Keystone Studios. He did not plan to remain in America, but World War II forced him to stay. He supported himself by taking on commercial assignments for fashion magazines and journals of interior decoration, and was under contract to Condé Nast Publications from 1949 to 1962. Simultaneously, he continued to enlarge and enrich his body of personal work.

## Herman Landshoff
German-American, born near Munich, 1905; died New York, 1986

Herman Landshoff was part of an artistic family: his father, a famous musicologist; his brother, a composer and conductor; and his sister, a sculptor. He became interested in photography at an early age. He studied design, planning to become a caricature artist. At his first job (as a designer in Munich) he worked for a Bauhaus artist who introduced him to photography. Fleeing Hitler, Landshoff arrived in Paris in 1933 and opened a photographic lab. He worked for French *Vogue* in 1935 and '36 and for the fashion periodical *Femina* in 1937 and '38. It was at this time that Landshoff did the outdoor shots of models dwarfed by zoo animals, which would later influence Richard Avedon's animal pictures for *Junior Bazaar* and one of his most famous fashion shots, *Dovima with Elephant*. In 1941 he immigrated to the United States, where he worked for *Mademoiselle*, *Harper's*, and *Junior Bazaar*. At Alexey Brodovitch's suggestion he attempted to reproduce the feeling of Brodovitch's ballet pictures, near-abstract photographs of movement, in the fashion idiom. The resulting photographs of models on roller skates and bicycles were the first blurred background fashion photographs—today a well known conceit.

## Jacques Henri Lartigue
French, born Courbevoie, France, 1894; died Nice, France, 1986

Born to a wealthy family, by the age of eight, Jacques Henri Lartigue was given a camera by his father. Thus began the endless coverage of his childhood, including automobile outings, family holidays, and his older brother Maurice's inventions. These photographs anticipated the best small-camera work of a later generation. He caught memorable images out of the flux of life with the skill and style of a great natural athlete—a visual athlete to whom the best game of all was that of seeing clearly. When Lartigue was sixty-nine his boyhood photographs were discovered by Charles Rado of the Rapho agency, who introduced them to John Szarkowski, then curator of photography at the Museum of Modern Art in New York, who, in turn, arranged a one-person show for Lartigue at the museum. From this exhibition, there was a photography spread in *Life* magazine, in 1963—in the same issue that commemorated the death of John F. Kennedy, ensuring the widest possible audience for Lartigue's pictures.

## Mary Ellen Mark
American, born suburban Philadelphia, 1940; lives in New York

Mary Ellen Mark began photographing with a Brownie box camera at age nine. She received a BFA degree in painting and art history from the University of Pennsylvania, in 1962, and a master's degree in photojournalism from the university's Annenberg School for Communication, in 1964. The following year she received a Fulbright Scholarship to photograph in Turkey. In the late '60s she moved to New York City and over the next several years developed a sensibility to capture the more troubled fringes. She has had a rich career shooting stills for over one hundred films, has been published in numerous magazines over the decades, and has had many books published as monographs. Mark has been known for touching upon key social issues, including homelessness, loneliness, drug addiction, and prostitution.

## Duane Michals
American, born McKeesport, Pennsylvania, 1932; lives in New York

Duane Michals's interest in art began at age fourteen while he attended watercolor classes at Carnegie Institute (Carnegie Museum of Art) in Pittsburgh. After two years in the Army, in 1956, he went on to study at Parsons School of Design, and began his professional life as a graphic designer. He describes his photographic skills as completely self-taught. Inspired by Robert Frank's work, Michals first used a camera in 1958 on a trip to Russia,

where he made simple portraits of working class subjects. Michals came to artistic maturity in the late 1960s, inspired by a visit with the aging Surrealist painter René Magritte in 1965. In 1966, he produced the first of his photographic sequences or as he called them "photo stories." Drawing from Surrealism, Magritte, and Zen Buddhism, Michals stages events that allow through captions and/or sequenced images, a mixture of mundane and fantastic elements to communicate psycho-dramatic stories.

### Arnold Newman
American, born New York, 1918; died New York, 2006

Over the course of his lengthy career, Arnold Newman became one of the most renowned portrait photographers of the twentieth century. He was born in New York and studied painting and drawing. For financial reasons he switched from painting to photography in 1938 but then he came to love photography. Newman began photographing as an apprentice in a chain portrait studio in Philadelphia. One insight he gained from this job was the importance of interacting with the people in front of the lens. In 1941 he moved back to New York from West Palm Beach where he managed a portrait studio and opened his own. In 1945, his first one-man show, *Artists Look Like This*, gained much attention and he began to freelance for *Life*. In 1946, he worked as a freelance photographer for *Fortune*, *Harper's Bazaar*, *Look*, *New Yorker*, *Esquire*, and *Newsweek*. He is often credited with being the first photographer to use so-called "environmental portraiture," capturing his subjects in their most familiar surroundings with representative visual elements. Among his most well known images are those of Igor Stravinsky, Harry Truman, John F. Kennedy, Pablo Picasso, Mickey Mantle, Marilyn Monroe, and Arthur Miller.

### Helmut Newton
German-Australian, born Helmut Neustadter in Berlin, 1920; died Los Angeles, 2004

Helmut Newton bought his first camera at the age of twelve and in the 1930s was apprenticed to the Berlin photographer, Yva, who was known for her nudes, fashion images, and portraits of dancers. He was compelled to leave Germany in 1938. He became an Australian citizen in 1945 and changed surname to Newton in 1946. In 1946, Newton set up a studio in fashionable Flinders Lane in Sydney and worked on fashion and theater photography in the affluent postwar years. Newton's growing reputation as a fashion photographer won him a commission in a special Australian supplement for *Vogue*, published in January 1956. He won a twelve-month contract with British *Vogue* and left for London in February 1957. He worked for various editions of *Vogue* from then on. In 1970, after having suffered a heart attack on a shoot he radically altered his style to the one known today: erotic, stylized scenes, often with sadomasochistic and fetishistic subtexts. During the '60s and '70s Newton worked for *Nova*, *Jardin des Modes*, *Elle*, *Queen*, *Stern*, *Playboy*, and the American, British, French, and Italian editions of *Vogue*. In 1975, he had his first solo exhibition in Paris of a series of huge portraits of glossy larger-than-life women, shot against a white backdrop. As a monumental tribute, in 1999, Taschen books published Newton's life work in *SUMO*. At 480 pages and more than sixty-five pounds it was the most expensive and largest book published in the twentieth century.

### Jeanloup Sieff
French, born Paris, 1933; died Paris, 2000

Jeanloup Sieff was born in Paris to parents of Polish origin. His interest in photography was first piqued when he received a Photax plastic camera for his fourteenth birthday. In 1954 he began shooting fashion photography after giving up the idea of working in cinema. He joined Magnum Photos in 1958. He settled in New York for a number of years in the 1960s where he worked for *Esquire, Glamour, Look*, *Vogue*, and *Harper's Bazaar*. He settled back in Paris in 1966 and continued to photograph for *Vogue* and *Nova*, filming over forty commercial movies. Dancers and nudes were two recurring themes in his work. A personal erotic vocabulary is evident in his nudes and fashion photography.

### Ben Somoroff
American, born Philadelphia, 1916; died New York, 1984

Ben Somoroff was introduced to photography by his childhood friend Ben Rose who also introduced him to Alexey Brodovitch. He was a key member of the "Philadelphia

School" of photographers (Irving Penn, Louis Faurer, Sol Mednik, Ben Rose, Arnold Newman, and Isadore Possoff), and came to New York City in the 1940s together with the group. He was a regular contributor to such magazines as *Harper's Bazaar*, *Vogue*, *Look*, and *Esquire*, to name a few. Some of his assignments for *Look* were exhibited at the Metropolitan Museum of Art as well as other prominent museums around the world. He is considered to be one of the preeminent American still life photographers of the twentieth century. In 1979 he had the great honor of being chosen by the United States Congress as the first photographer to be commissioned to create the first photographic postage stamp commemorating photography.

## Bert Stern

American, born Brooklyn, 1929; lives in New York

At the age of seventeen Bert Stern took a job in the mailroom of *Look* magazine. Within three years, in 1949, he became an art director for the fashion magazine *Mayfair*. During the Korean war he was stationed in Tokyo. When he returned to the U.S., in 1953, he was awarded the contract for advertisements for Smirnoff Vodka. In 1954 he worked as an editor for *Fashion & Travel* magazine, but soon abandoned layout to concentrate on his successful commercial photography. Stern set a hectic pace as the quintessential fast-living photographer of the '60s, doing advertising photography for such firms as American Cyanamid, Canon, DuPont, Pepsi-Cola, U.S. Steel, and Volkswagen. The advertisements tended more and more toward portraits for editorial and in 1960 he shot a successful *Vogue* cover. Two years later, over a three-day period he shot 2,500 photographs of Marilyn Monroe, just six weeks before her death. (This iconic body of work was published as *Marilyn Monroe: The Complete Last Sitting*.) His celebrity portrait sittings also include those with Madonna and Lindsay Lohan (with whom he recreated the infamous "Last Sitting" images of Monroe).

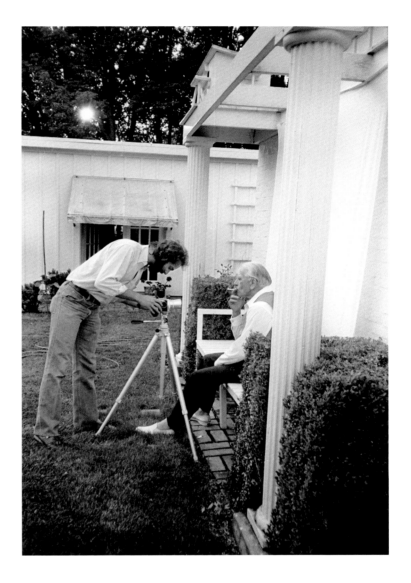

Simply, without the devotion, passion, and the commitment of Regina Monfort to my work this book would never have been. I am deeply grateful to you.

A special thanks to Bill Ewing for following my work all these years and contributing his significant well of wisdom, authority, and experience to my career. My thanks also to his curatorial researcher Lydia Dorner who provided much needed help.

There is no way to overstate the contribution Julian Sander has made in championing my work. His commitment, good taste, guidance, and friendship mean more to me than words can tell. I am honored by his unending belief in me.

Special thanks to Eileen Boxer for her wonderful design. Her experience and conceptual understanding of the project from the start went a long way in making this book a special "moment."

There may be no better "separator" than Robert Hennessey. Having Bob on any photographic book project is a true privilege. Thank you for bringing the full force of your experience to bear on making sure the pictures look as they do.

I am privileged to have Diana Edkins as a dear friend. Her commitment, intelligence, and knowledge of photography significantly impact every project I share with her, all the more so with this one.

Each photographer I photographed gave their time and life experience in support of my career. I am deeply grateful to have known these giants, to learn from them, and have had the chance to stand on their shoulders. I hope that this book in some small way, pays homage to their immeasurable contribution to the way we all see the world.

Above and beyond, my everlasting appreciation to my family: Aaron, Sofie, Illiana, Lara, and of course, for her constant patience and love, my wife Irina Somoroff.

For their presence, patience, persistence, advice and guidance, my sincere gratitude goes to:

The Publisher.
Andrea Albertini, Damiani
Bologna, Italy

The Curator.
William A. Ewing

The Foreword.
Julian Sander

The Galleries.
Feroz Gallery, Bonn
Thomas Schulte Gallery, Berlin

New York.
Tom Bentkowski, Eileen Boxer, Anthony DeMaio, Kyra DeMarco, Diana Edkins, Michael Frankfurt, Steve Frushstick, Nick Fuglestadt, Alex Galan, Robert Hennessey, Lizzie Himmel, Mun Kyeom Kim, Regina Monfort, James Salzano, Michael Salzer, Andrea Smith, Alison Smith, Sam Wool

Amsterdam.
Susan Zadeh

Berlin, Hamburg, Köln.
F.C. Gundlach, Wolfgang Behnken, Thomas Schulte, Dieter Ziebig

Bologna.
Eleonora Pasqui

Los Angeles.
Brian Power

Milan.
Enrica Viganò, Lucia Orsi

Tucson.
Sue Moss, Alice Somoroff

The Printers.
Arkady Lvov, Sid Kaplan

The Retouchers.
Ray Benjamin, Gabe Greenberg

**A Moment.**

**Master Photographers: Portraits by
Michael Somoroff**

© Damiani 2012
© Photographs, Michael Somoroff
© Texts, Julian Sander, William A. Ewing,
Michael Somoroff, Diana Edkins

Design by Eileen Boxer

DAMIANI

Damiani
via Zanardi, 376
40131 Bologna, Italy
t. +39 051 63 56 811
f. +39 051 63 47 188
info@damianieditore.com
www.damianieditore.com

Tritone separations by Robert Hennessey
Editing by Susan Ciccotti
Production 2012 by Stativ Ltd. Inc. New York, NY 10012,
© Stativ Ltd. Inc.

www.michaelsomoroff.com

Printed in June 2012 by Grafiche Damiani, Italy

ISBN 978-88-6208-211-2

→

. . .